THE LITTLE BOOK
OF TREES

THE LITTLE BOOK OF TREES

Dominique Pen Du

CONTENTS

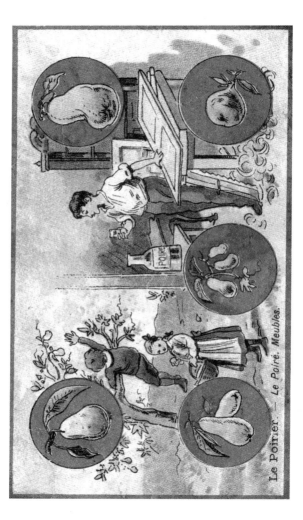

Le Poirier — Le Poiré. Meubles.

THE LONG HISTORY OF TREES

There were trees growing on the planet long before we even existed. They are believed to date from the Devonian Period, 395 million years ago. Until then, plants had been limited to algae, mosses and ferns. Like ferns, the first woody plant, comprising a trunk and branches (the definition of a tree), reproduced by means of spores. Known as *Archaeopteris*, it could grow to the dizzying height of 50 metres.

Prehistoric trees

In the Carboniferous Period (about 345 million years ago), the descendants of *Archaeopteris* grew very quickly, but died just after producing spores. However, a remarkable evolution was underway. Trees were producing flowers and seeds, and they were beginning to reproduce by pollination. The first specimens of trees that resemble those we know today were evergreen. But tremendous temperature differences led to the development, and later predominance, of deciduous plants, which were better able to protect themselves against frost and drought. The existing species were mixed without territorial differentiation. Continental drift would lead to their separation, after which they would evolve differently. During the Pliocene Epoch (ten million years ago), successive glaciations took their toll on plant life. Only the hardiest trees survived.

Waves of harsh cold affected the northern hemisphere, followed by periods of intense heat. On the American and Asian continents, trees were able to migrate towards the south and continued to thrive by colonizing new areas. In Europe, however, the Mediterranean Sea and Pyrenees mountain range formed a barrier. Most species became extinct, except for oaks, willows and elms, and a few others.

Humans and trees

Human intervention would bring about major changes. As a result of their military campaigns in eastern regions, the Greeks and Romans brought back species whose benefits they had come to appreciate. They successfully introduced fig, olive and walnut trees all over the Mediterranean region. This would also give rise to new varieties. The trees of the genus *Prunus*, for example, with a common ancestor, developed into the plum, apricot, peach, almond and cherry trees, among others. The use of wood would gradually be refined as the qualities of each species were identified: strength for construction, water resistance for shipbuilding, flexibility for musical instruments, fineness of grain for fine furniture, and so on.

Trees, gods, myths and legends

The impressive stature of giants such as the oak or ash is awe-inspiring. Believing all natural phenomena to be the result of supernatural forces, ancient societies came

to worship trees that were familiar to them. In Greek and Roman mythology, trees would embody deities or would be dedicated to them. Their miraculous births were told in myths that combined the characteristics observed in the tree and the temperament attributed to one god or another. Similarly, Germanic, Scandinavian and Native American peoples, and the inhabitants of Asia and Africa, created myths involving trees. The fascination for trees would endure through popular tales and legends. The forest was home to wild animals that were not always friendly, and often to individuals with evil intentions. Gloomy, at times impenetrable and disturbing, it was a place to get lost in, and also to hide, which is what fairies, wizards, witches, goblins, elves and many other creatures born out of human imagination would do. From Little Red Riding Hood to Harry Potter, the forest would become the setting for delightfully terrifying adventures.

The trade in trees

Myths and beliefs were to gradually give way to more pragmatic concerns: the laws of commerce. Since the Middle Ages, fruits and spices had been arriving in Europe from the Middle East. These goods were rare and very expensive. The crusaders returned with species that they introduced and exploited in the West. They would, however, encounter the challenges of climate. For instance, the orange tree would never become acclimatized north of the Pyrenees. Missionaries in Asia,

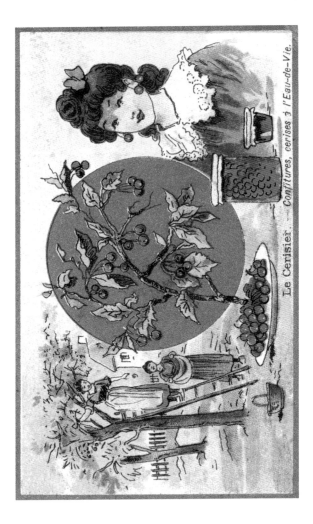

Le Cerisier. — Confitures, cerises à l'Eau-de-Vie.

on the other hand, would successfully bring back the white mulberry bearing silkworms, allowing Europe to break the Chinese monopoly on the production of silk. Through the great seafaring expeditions of the seventeenth century, the European powers discovered species from North and South America and the Caribbean. Fierce competition was unleashed by the trade in logwood dye, cocoa, mahogany and rubber. And in Asia, battles would be waged over nutmeg and cinnamon. It was no longer a question of importing new species, but of dominating their production at their place of origin, and exporting them. Over-exploitation would begin to take its toll.

When science became involved

Not all of those seafarers were traders. Eighteenth-century botanists, enamoured of both science and beauty, would import species simply for their decorative appeal. But more importantly, they would undertake to classify them. Carl von Linné, known as Linnaeus, had the idea of assigning universally acceptable names to trees. He chose Latin for this purpose, and he divided the species into genera and families.

Vernacular names continued to be used. The multiple regional and local names are a testament to the association between humans and trees that has existed for thousands of years.

SPANISH FIR
Family **Pinaceae**
Genus *Abies*

The common name of the conifer *Abies pinsapo* is clearly taken from its place of origin. It was growing in a curtailed area high in the Sierra de Ronda mountains of southern Spain when it was identified by the Swiss botanist Edmond Boissier in 1838. In the early twentieth century, a relative of this tree was discovered growing in the mountains near Tetouan in Morocco, which was immediately christened *Abies pinsapo var. marocana*, the Moroccan fir. The Spanish fir is suited to growing in poor soils. Though native to a hot country, it is also able to withstand the cold at high altitude (up to 1,800 metres), and this hardiness allowed it to adapt to the conditions of northern Europe. From Switzerland to Britain, and from Denmark to Sweden and Finland, where it grows tallest, it made carpenters happy. The carpenters of the Savoy and Jura regions of France chose this wood to make their traditional toys. The quality of the wood from this tree led to over-exploitation that almost caused the tree to become extinct in its native country of Spain. The Spanish fir has dense, thick and hard foliage, and it retains its lower branches for a long time. Thanks to the characteristics of its foliage, this tree became very popular in ornamental gardens because, while it easily withstands drought, wet climates do not pose much of a problem for it.

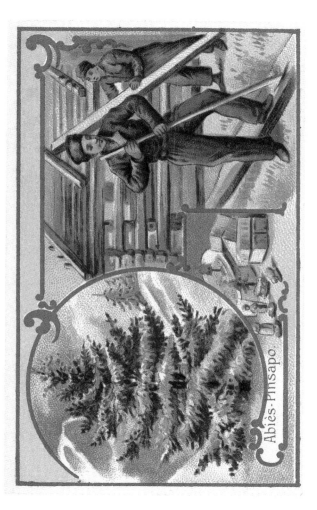

Abies-Pinsapo.

APRICOT TREE
Family **Rosaceae**
Genus *Prunus*

The Romans believed this tree to be a native of Armenia, which is the reason for the name they gave it: *prunus armeniaca*, the 'Armenian plum'. However, this country in the Caucasus region was only a stage on the long journey made by the apricot tree, which followed the silk route from Manchuria to the Mediterranean, via Persia. This tree has grown in China for five thousand years, but only arrived in France in the early sixteenth century, perhaps brought back by King Francis I on his return from the Italian Wars. Not fond of damp climates, the apricot thrived in its new home in the Roussillon region of France, making the country one of the world's leading apricot producers. Its French name, *abricot*, is derived from the Catalan *abercoc*, 'early ripe', because it flowers early in the year, immediately after the almond tree. This particularity makes it vulnerable to spring frosts, and leads to irregular production of fruits. In good years, harvests are short and plentiful. Luckily, apricots are quite suited to preserving, by drying and as a paste or jam. Their kernels can be used to make liqueurs, among them the famous Italian amaretto. They can also be eaten raw, but in small doses as they can be poisonous. The apricot tree is associated with Venus, the Roman goddess of love. This was the inspiration for an Andalusian custom whereby women would put a few apricot leaves and flowers under their skirts to make themselves irresistible.

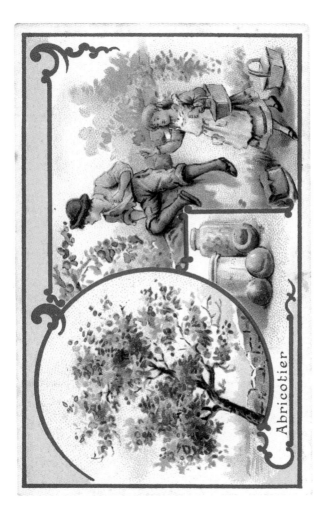

Abricotier

BLACK LOCUST
Family **Fabaceae**
Genus *Robinia*

The name by which the black locust is known in France, acacia, is also that of a botanical genus, but this tree is not part of it. It is because it is also known as the false acacia, from its scientific name *Robinia pseudoacacia*. The genus is named after Jean Robin, royal gardener to King Henry IV of France, who planted the country's first specimen in the garden of the church of Saint-Julien-le-Pauvre in Paris. It is now the oldest tree in the city. It was brought back by a seafarer from Virginia, in the United States. As it was suited to poor soils, it quickly colonized the countryside and towns of France. Some people complain about the fact it grows quickly and is resistant to pollution, turning it into an invasive species. However, it is also praised for its role against land subsidence in deforested areas. Black locust wood is hard and poisonous, protecting it from insects. It was once used to make wheels and carriages. It is still used today to make trellis posts for training grapevines. In carpentry, it makes an interesting local alternative to the over-exploitation of tropical rainforests for exotic hardwoods. But this tree comes into its own when spring returns. It is truly a pleasure to breathe in the gentle fragrance released by its clusters of white blossoms, which are used to make perfume and to add a delicate flavour to fritters, syrups and alcoholic beverages. The large amount of nectar in the flowers attract bees, which make from it a honey renowned for its fine taste.

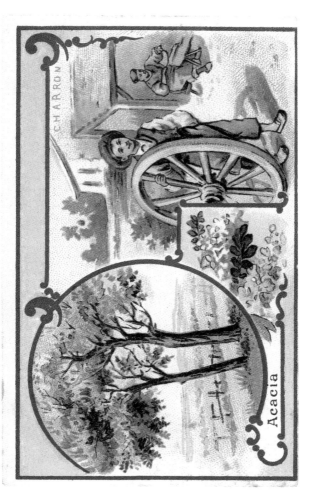

CHARRON

Acacia

MAHOGANY TREE

Family **Meliaceae**
Genera *Swietenia, Khaya* and *Cedrela*

This tree first evokes the colour to which it has given its name, a reddish brown with warm undertones. However, it only turns this colour as it ages. When freshly cut, it is a pinkish grey colour, turning deep purple in contact with the light. It then calls to mind the precious hardwood with a very fine grain that is easy to work and polish to a glossy finish, which is carved or used to make high-quality furniture. Mahogany tree is a generic and popular name, but not a scientific one, and in fact refers to a number of different species, all tropical. Genuine mahogany is the term used to define the genus *Swietenia*, which is native to Central America and Jamaica. The genus *Khaya* is used collectively for the African mahogany species. The Chinese mahogany tree was first identified by the French Jesuit and botanist D'Incarville in the mid-eighteenth century. It was described in 1830 by Adrien de Jussieu, who named the genus *Cedrela* owing to its resemblance to cedar. It is the only one that can grow in a temperate climate. Another word for the mahogany tree, acajou, is also the local name for a tree native to northeastern Brazil which produces a popular snack, the cashew tree.

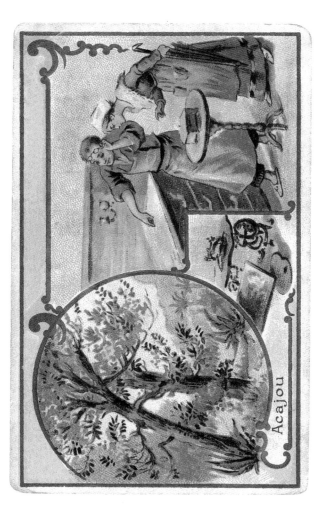

Acajou

ALMOND TREE
Family **Rosaceae**
Genus *Prunus*

Having taken root in the mountains of Afghanistan and Turkistan, this tree spread toward the Persian Plateau (in present-day Iran), where it has been cultivated for five thousand years. It went on to colonize Anatolia and then Palestine and Egypt. The Greeks introduced it into Europe and the Arabs into North Africa. In France, the almond tree is most at home on the hot and dry Mediterranean coast. An almond tree found growing wild may be of the *amara* variety. But take note; its fruits, bitter almonds, are poisonous except in very small doses. The *sativa* variety produces tasty sweet almonds. It is these almonds that are cooked with milk to make orgeat syrup, ground as an ingredient for cakes and confectionery, eaten raw or dried, or pressed to produce a fine oil with emollient properties for use in the pharmaceutical and cosmetic industries. These almonds were given pride of place in the French cuisine of the Middle Ages because our ancestors were undoubtedly familiar with their benefits. The explanation for this is clear today: sweet almonds contain as much protein as meat, as well as a wide range of vitamins and minerals.

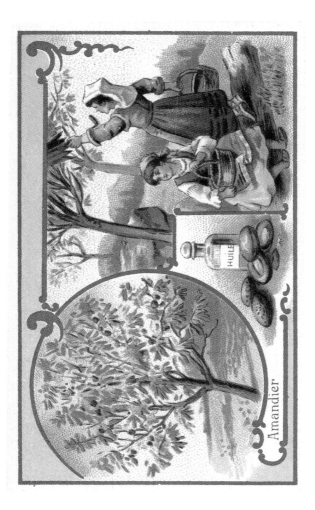

HUILE

Amandier

MONKEY PUZZLE
Family **Araucariaceae**
Genus *Araucaria*

This conifer received the name monkey puzzle because it was believed that it would puzzle a monkey to climb the tree, given its hard and very prickly leaves. Its scientific name, *Araucaria araucana*, is derived from that of the native Araucanian (Mapuche) people of central Chile, where Europeans first identified it in the eighteenth century. There are 15 species within the *Araucaria* genus, all native to the southern Hemisphere and found in South America, New Guinea, New Caledonia, Australia and other parts of Oceania. The Norfolk Island pine, *Araucaria excelsa* ('very tall'), which grows to a height of 70 metres on its native Norfolk Island, Australia, has become very popular in Europe ... as a house plant! Araucarias dislike frost and require a mild and wet climate. The monkey puzzle, formerly named *Auracaria imbricata* ('overlapped') because its leaves are overlapped like roof tiles, has been successfully grown outdoors in France. It prefers the Atlantic coast over the dry Mediterranean regions. Its edible seeds resemble pine nuts. The English botanist Archibald Menzies, who was travelling the Andes in search of species suitable for shipbuilding, was served these seeds for dessert, giving him the idea of bringing some back with him to the northern Hemisphere in 1795. However, the monkey puzzle was only able to spread in this part of the world after being tended for half a century in a greenhouse.

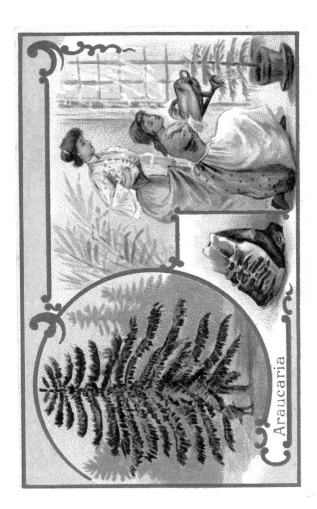

Araucaria

ARECA PALM
Family **Palmaceae**
Genus *Areca*

The areca palm is also known as the betel tree. On the island of Madagascar, where it probably originated, and throughout Asia, it grows to the respectable height of between 10 and 12 metres. Its hard, white wood is suited to making boards, and its fronds are used for roofs. Its fruit, the areca nut, produces a sweet oil. It is also a basic ingredient of betel nut, for which it is chopped or grated, mixed with lime or tobacco, and wrapped inside a betel (*Piper betle*) leaf. Very popular in Asia, this preparation is chewed, and the excess juice spat out. Betel nut is a stimulant and acts as an appetite suppressant. However, excess consumption can lead to addiction and may cause cancer. These uses for areca are not habitual in our part of the world, yet we are very familiar with it because it is the most popular palm in homes. It has a single trunk with long, curved fronds of a lovely green, and sometimes orange or bright yellow oval fruits. It is an easy-going house guest, provided it is not subject to temperatures below 16 degrees Celsius, and has a cleansing effect: it humidifies the air and absorbs the smell of tobacco smoke.

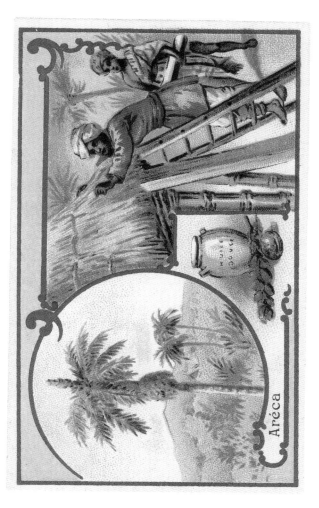

Aréca

HAWTHORN
Family **Rosaceae**
Genus *Crataegus*

The hawthorn is a large and beautiful family comprising several hundred species distributed across the temperate regions of the northern Hemisphere, mostly in North America. There are only three species indigenous to France, among them the azarole that grows in the south, which arrived from Asia via Spain. The presence of seeds in the remains of prehistoric lakeside settlements suggests that early humans were already feasting on tempting red hawthorn berries, known as haws. Haws are scarcely consumed today and are only used to make jams, jellies, syrups and liqueurs, and in the production of medicines. Turners value highly the very hard wood of the hawthorn, and this versatile and hardy shrub continues to be planted in hedges. The hawthorn is able to adapt to all soil types, which led it to be considered a symbol of happiness and prosperity in ancient times. In the Middle Ages, knights leaving to fight in the Crusades would give their lady a hawthorn branch as a token of their fidelity. Because this tree blooms in May, which for the Romans was the month of the Pleiad nymph Maia, it was considered sacred to her. And even if people no longer believe, as they did in the Middle Ages, that the hawthorn in bloom heals sick children, its masses of white flowers are always pleasing to the eye.

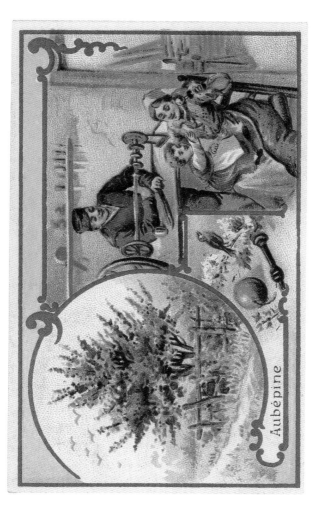

Aubépine

BANANA TREE
Family **Musaceae**
Genus *Musa*

While everybody is very familiar with bananas, the banana tree is rather unknown. Despite its slender stem (which grows up to 12 metres, depending on the species) and its large drooping leaves, it is not actually a tree but a plant. After producing a single bunch of bananas, the stem dies. Only its rhizome survives, from which a new banana tree will emerge in the following season. The leaves, which no longer serve the plant after the harvest, are recycled as roofing material, as wrappers and woven into objects. As bananas reach us from Africa, or more often Latin America and the Caribbean countries, we tend to think that the banana tree originated in those places. That is incorrect; this plant is from Asia (India, Melanesia, Indonesia, New Guinea). Europeans introduced it to the Americas at the start of their colonization in the sixteenth century because it was suited to any rich soil in the tropics. While cooking bananas or plantains are not particularly popular in Europe, the sweet banana, of which Cavendish is the most common variety, is today a source of lucrative trade, with its share of conflicts between producing countries and multinational exporting companies. And to think that Buddha had considered the banana tree as a symbol of the vanity of goods! A special species of banana tree, abaca, is grown in the Philippines for its strong fibre, which is used to make rope and clothing.

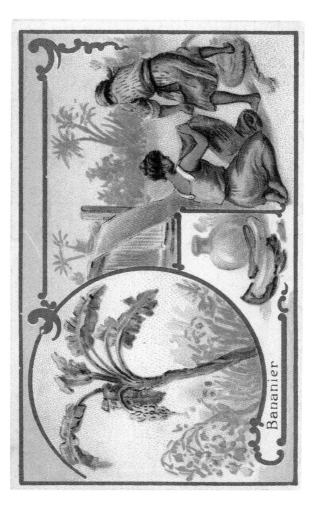

Bananier

BAOBAB
Family **Bombacaceae**
Genus *Adansonia*

Two Arabic terms are thought to be the origin of this tree: *iobab*, 'nut', or *buhibab*, 'fruit with many seeds'. This child of the savannah grows in tropical Africa, Madagascar and Australia. It is the emblem of Senegal, the palaver tree under which people gather to take in the words of elders or to listen to storytellers. The baobab is distinguished by the impressive width of its trunk, which can grow up to 30 metres in circumference. Its narrowing top has earned it the nickname of bottle tree. In fact, the tree actually contains up to 120,000 litres of water, which explains its high resistance to drought. This tree grows very slowly, and boasts a record longevity of two thousand years. Its gourd-like fruits, known as monkey bread, have a pulp that is rich in vitamins and calcium. They also contain a large number of highly nutritious seeds that are roasted and eaten. They are also pressed to extract an oil, which is used to make soap and fertilizer. The gourds can be dried to make maracas. The dried and ground leaves are used in culinary preparations. The bark, reputed to act as a fever reducer in decoction, is also used to make a strong rope. There are few uses for the wood, which is too saturated with water for use in building. However, venerable baobab trees are rarely felled, because the shade it offers, although meagre, is prized in these arid lands.

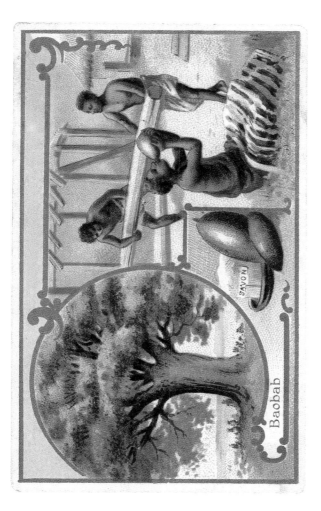

Baobab

SAVON

BIRCH
Family **Betulaceae**
Genus *Betula*

The hardiest of broad-leaved trees, the birch is suited to poor soils, drought and extremely wet climates. It is the only tree native to Arctic and subarctic regions, where it can live for 100 years, and it is one of those pioneer plant species that leads the colonization of an open area. The genus *Betula* includes a large number of species originating in North America and China. What they have in common is a graceful bearing and shiny bark, which is often white or orange-brown. The silver birch is very common in Europe, where it is also known as the weeping birch because of its weeping branches embellished with catkins. As the years pass, its bark turns from a golden colour to silver, and becomes so thick and impenetrable that the people of the Nordic countries once used it to make roofs. Young birch branches, both supple and strong, were used by the Romans to make rods for flogging prisoners. They were later given a more pleasant use by tying them together into brooms. The sweet sap of this tree is known as birch water. The peoples of the far north of Europe and North America would ferment the sap to make wine, which they would use to treat skin conditions, urinary problems and rheumatism. The light and uniform wood of the birch is easy to work. It is mainly used to make ice lolly sticks and tongue depressors. Birch contains a great deal of essential oils and burns well, making it particularly good for firewood.

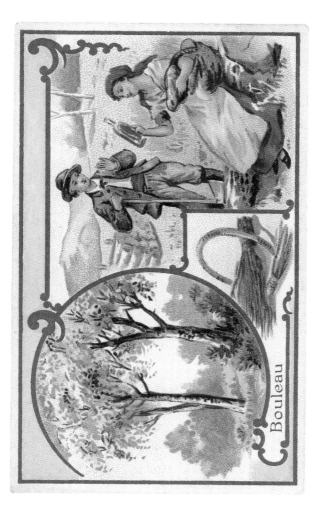

Bouleau

BOX
Family **Buxaceae**
Genus *Buxus*

———

In ancient times, the remarkably slow growth, great longevity and evergreen foliage of box made this shrub a symbol of immortality. The Christian custom of blessing box branches on Palm Sunday, and keeping the branch for the entire year next to a crucifix, is probably of pagan origin. The Romans used hard, compact and smooth boxwood to make wax tablets for writing. These qualities were later put to use in printing, with engraved blocks of boxwood used for illustrating books and newspapers. The ability of the wood to resist fire meant that it was long sought as a material for small kitchen utensils and tobacco pipes. Box is also known as a traditional ornamental plant in the French gardens of the seventeenth century, where it was clipped into the most whimsical forms. In Roman times, box was already being clipped into animal shapes, and Renaissance gardeners used it to create mazes that became very popular with lovers. This delicate work could last because box grows very slowly and remains green throughout the year. But if you find it growing wild in Provence, you will notice it is covered in small and unassuming yellow flowers in spring, which in September develop into fruits whose sweet juice is a special treat for bees.

———

Buis

COCOA TREE
Family **Sterculiaceae**
Genus *Theobroma*

The cocoa tree, also known as the cacao tree, was considered sacred by the native peoples of Central America, where it originated. According to a Mesoamerican legend, the Feathered Serpent, the Aztec god of vegetation, brought it to life from the blood shed by a Toltec princess who had been heroic in death. When the Spaniard Cortes and his conquistadors came into contact with the cocoa tree in the late fifteenth century, they did not at first appreciate the beverage made by the natives from its fruit. The tree was so precious to them that cocoa pods were used as currency. Later, when the growing of sugar cane was introduced to the Caribbean, the colonizers came up with the idea of heating the beverage and adding spices and sugar to it. Their discovery turned into a gold mine. The export of cocoa to Europe became one of the legs of the triangular trade that developed in the seventeenth century from the slave trade. The cocoa market still presents considerable economic challenges. While introduced into all tropical regions, cocoa trees are mainly cultivated on smallholdings by farmers who are quite likely to abandon their activity because of a lack of fair trading conditions that allow them a decent living.

Cacaoyer

LOGWOOD
Family **Fabaceae**
Genus *Haematoxylum*

This tropical tree of modest size was for centuries a resource of considerable economic importance. Logwood is native to Mexico, although it was taken to the Antilles and other Caribbean regions prior to European colonization. The Aztecs were the first to discover that the wood of this tree was full of a blood-red sap that made an excellent dye. The Spanish colonizers of the region capitalized on this. The wood was exported to Europe from the port of Campeche, on the Gulf of Mexico, giving rise to one of its names, campeachy wood. A dye known as haematoxylin was extracted from it. Depending on how it was processed, colours ranging from blue to red were the result, including the entire range of purples and black. The arrival of haematoxylin in Europe overwhelmed the market, dominating it completely in the eighteenth century, to the detriment of the natural dyes produced in the West. This competition between products caused conflict between the two giants of global trade of the time, England and Spain. Logwood was not unseated until the middle of the twentieth century by synthetic dyes. Logwood is still exported from the Caribbean on a small scale. Although no longer used fraudulently to colour wine, it is still prized in marquetry. The leaves of the logwood tree are believed to have medicinal properties: fever-reducing properties in decoction and skin-healing properties when used in a poultice.

Campêche

CAMPHOR TREE
Family **Lauraceae**
Genus *Cinnamomum*

This relative of the bay tree and cinnamon tree takes its name from the precious substance obtained by the distillation of its wood, camphor. From the Middle Ages, it journeyed by land and sea to Europe from Japan, China and the Malay Peninsula. In the course of this journey, its Malay name *kapur barus* ('chalk of Barus', in relation to its whiteness and the name of the Indonesian port from where it was exported) became *kafur* in Arabic and *camphora* in Latin. Camphor's many medicinal properties have long been known and appreciated. The Chinese used the substance to embalm their deceased emperors. Because it is an effective antiseptic, camphor was used to stave off epidemics. In the form of a cream, it soothes muscular or rheumatic pain and clears the bronchial tubes. It also has anaesthetic properties, although in the case of overuse, there is a risk of never waking up again. In the past, as the lingering smell of camphor repelled mites, chests were made from camphor wood and used to store fabric and furs. The first specimen to be brought to France, planted in the Jardin des Plantes, the botanical garden of Paris in 1760, did not flower until 45 years later. The camphor tree would later have great success as a purely ornamental plant in regions of the world with mild climate, such as California and along the shores of the Mediterranean Sea.

Camphrier

CINNAMON TREE
Family **Lauraceae**
Genus *Cinnamomum*

The Queen of Sheba and Emperor Nero were said to adore cinnamon. It is mentioned in the Bible, and in Chinese medical treatises that are thousands of years old. Its aphrodisiac quality is revealed in *The Thousand and One Nights*. Cinnamon was an ingredient of hippocras, a sweet and strongly spiced wine enjoyed in the Middle Ages. This pioneer of the spice trade is obtained from the bark of the cinnamon tree, which is grey on the outside and reddish brown on the inside and harvested twice a year from the young branches. Only the inner bark is used. It curls up as it dries. The finer the bark, the stronger and more delicate the aroma. The distillation of cinnamon chips produces an essential oil that is used to make pharmaceuticals, perfumes and cosmetics. In India, where cinnamon originated, the spice is used to treat colds and intestinal disorders. The *Cinnamomum zeylanicum* species from Ceylon, modern-day Sri Lanka, is also known as *Cinnamomum verum*, 'true cinnamon', because it has been used since ancient times. However, *Cinnamomum aromaticum*, Chinese cassia, is a serious competitor. It has thicker bark and a less refined taste, but it produces more essential oil. As they are cheaper, cassia bark and oil have flooded the market.

Cannelier

RUBBER TREE
Family **Moraceae**
Genus *Castilla*

The word 'rubber' is given to the material produced from the latex secreted by certain trees and tapped through cuts made into the trunk. Several plant species produce latex: the caoutchouc or Pará rubber tree, which grows in the Amazon region; *Ficus elastica* or rubber fig, a member of the same genus as the fig and banyan tree, and which has become very popular as a house plant; *Castilla elastica* or Panama rubber tree, which is from the same family as the former; and the guayule, which is typical of Mexico. All of them are tropical. The natives of Central and South America revered latex. Using clay moulds, they made it into many objects, such as the balls used for their sacred games. They also used it to coat cloth and believed it had medicinal properties. The first European colonizers did not pay much attention to this material until the eighteenth century, when French naturalists came to study it. The French word for rubber, *caoutchouc*, is a transcription of the name given to the tree by the natives, *cahuchu*, 'crying tree'. Chemists in the West would later find more and more properties and applications through progressively complex processes. The invention of synthetic rubber in the early twentieth century was not the end of natural latex. Caoutchouc plantations were also created in Southeast Asia. The other, less productive species of rubber trees, have found success as ornamentals.

Caoutchouc (Castilloa Elastica)

CEDAR
Family **Pinaceae**
Genus *Cedrus*

According to legend, the first cedar specimens were brought to France in 1734 by the botanist Bernard de Jussieu, carried from Lebanon in his hat. How many plants? According to authors, between two and four. One still flourishes in the Jardin des Plantes botanical garden in Paris. The town of Ballans, in the Charente-Maritime region, is proud to possess another. But while it is accepted that Jussieu brought them to France, it appears that they had been given to him in England, where this majestic conifer had been widely established a century earlier. The cedar of Lebanon is not the only species of cedar found in France. The Atlas cedar thrives on the Mediterranean coast, and the weeping Himalayan cedar is found in the southwest region of the country. This tree has been venerated in the Middle East since ancient times. The Mesopotamians regarded it as a protector against demons. Like the Egyptians, they also used its wood to make the doors of their temples. It is mentioned in both the Bible and the Koran. The cedar today is the emblem of Lebanon. In ancient times, the rot-resistant wood from this tree was highly suited to shipbuilding and the making of sarcophagi. It gives off a particular smell, which is generally pleasant to humans, but not to insects. Clothes hangers are made from cedar wood to repel clothes moths. The essential oil that has been extracted from cedar has been used in cosmetics and medicines for centuries.

Cèdre

CHERRY TREE
Family **Rosaceae**
Genus *Prunus*

The inhabitants of the lands surrounding the Mediterranean Sea were familiar with only one wild species of cherry bearing sour fruits when the Roman consul Lucullus, having defeated Mithridates in the first century BC, brought back the sour cherry tree among his trophies from the expedition to Asia Minor. The battle had taken place near the Black Sea at Cerasonte, which is the origin of the French word *cerise*, and the English word cherry. Although the story of the sour cherry is famous, Lucullus also appears to have introduced another variety of wild cherry tree, the forerunner of the trees that bear sweet cherries. These are the cherries we eat raw. Sour cherries are used to make preserves, liqueurs (kirsch and maraschino) and brandied cherries. Other cherry trees were introduced from Asia in the nineteenth century for purely decorative purposes, given that they do not bear fruit. When they flower, twice a year for some varieties, they are covered in masses of white or pink blossoms. They are known as ornamental cherry trees. Among them is the Japanese cherry, which flowers for a short time, and whose blossoms are known by the Japanese as *sakura*. For the Japanese, *sakura* represents the essentially ephemeral nature of life and its beauty. It is also associated with samurai class. For centuries, Japanese artists in all disciplines have found inspiration in these blossoms. They are depicted on kimonos and everyday objects, and Sakura is also popular girl's name.

Cerisier

SWEET CHESTNUT
Family **Fagaceae**
Genus *Castanea*

The sweet chestnut tree can live for up to a thousand years. This tall and mighty tree with gnarled roots was considered a symbol of virility in ancient times. It is a highly sociable species, growing well in poor soils without disturbing the surrounding vegetation. There is only one thing it cannot bear: extreme cold. The word chestnut comes from the French *châtaigne*, which is derived from the ancient Greek town of Kastanea, now in modern-day Turkey, from where the Romans carried it home. After receiving it from their conquerors, the Gauls soon prized it. The fruits of the tree, chestnuts, are a very nutritious food source that can be stored for a whole year. The inhabitants of regions with poor or irregular cereal production came to rely on chestnuts in times of scarcity. This accounts for their popularity in Brittany and the Cévennes regions of France. Chestnuts are used in many savoury and sweet preparations, from chestnut flour to confectionery, including delicious *marrons glacés* or candied chestnuts, invented in Alès. The sweet chestnut tree also provides fine lumber, whose smell repels flies, and therefore spiders. It used to be made into a light charcoal, which was ideal for use in forges. But it also has its weaknesses: ink disease attacks the roots and bark of the trees; while ring shake makes the trunk hollow without any external signs, much to the annoyance of loggers.

Châtaignier

OAK
Family **Fagaceae**
Genus *Quercus*

The oak tree grows slowly, and is therefore planted for future generations as a symbol of hope. Its impressive size (up to 40 metres in height and 2 metres in diameter) and remarkable longevity (at least 400 years) impressed the ancient Gauls. They considered it sacred and gave it the name *cassanus*, from which the French word for the tree, *chêne*, is derived. The Germanic peoples dedicated it to Odin, the mightiest of their gods. The ancient Greeks believed that oak trees were inhabited by dryads or tree nymphs. The Romans made it a symbol of strength and integrity. The fact that it became the most common tree in French forests did not diminish its prestige. However, since the Middle Ages, humans have particularly valued it for the many uses it serves. The sturdiness of its wood makes it a material of choice for building, flooring, ships and barrels for ageing wine, brandy and whisky. This is combined with a very fine texture that appeals to carpenters, cabinetmakers and sculptors. An added advantage is that the oak tree is resistant to insects and fungus because of its high tannin content. This particularity was not lost on tanners, who would use its bark to turn hides into leather. Oak galls or oak apples, ball-shaped growths on the leaves caused by the gall wasp, were used to make ink until the nineteenth century. Acorns have a less noble mission, which is to feed pigs.

Chêne

LEMON TREE
Family **Rutaceae**
Genus *Citrus*

This tree bears the venerable name *Citrus limon*, from which the word lemon is derived, and lemonade, a beverage made from its juice combined with water and sugar. The origin of this name, after many transformations, was the Sanskrit word *nimbu*, a reminder that this shrub is native to the Himalayas. The citron tree, another species of citrus, is believed to be the ancestor of the wild lemon tree. Through hybridization with the lime tree and grapefruit tree, it gave rise to the tree we cultivate today for its fruit, which are rich in vitamin C. The proliferation of the lemon tree in Europe is attributed to Alexander the Great. This tree, which prefers sunny locations, quickly became established in the Mediterranean region, where its particular ability to flower and bear fruits in every season earned it prestige. Seafarers in the past held it in great regard because its fruit was a cure for scurvy. The list of other benefits of the lemon tree is an especially long one. Greek, Roman and Arab physicians were already familiar with the antiseptic properties of its fruits. Lemon juice is an ingredient of grandmothers' recipes, which proved to be effective for sore throats and mouth ulcers, for skin, strengthening nails and hair, and curing hiccups, among others. The zest, which contains the essential oils, concentrates the aromas of the fruit, which is even stronger in Menton and Corsican lemons.

Citronnier

COCONUT PALM
Family **Palmaceae** or **Arecaceae**
Genus **Cocos**

Nobody knows exactly when this palm appeared. It spread throughout the islands of the Pacific Ocean and the Far East, where it was carried in part by seafarers, and in part by marine currents. Its fruits actually float on water for a long time without deteriorating. And wherever they came ashore, they would germinate and put out shoots. It should be pointed out that everything about the coconut palm is good. Before maturing, the coconut contains a very refreshing sweet liquid. It later develops an edible pulp or meat, copra, which can be grated and squeezed to make coconut milk for use in cooking, or an oil for use in cosmetics, including the famous monoi oil. Coconut shells cut in half can make receptacles or the bras used by Polynesian dancers. The fibre that surrounds the internal shell is called coir. It is strong enough for use in making brushes and rope. The fronds are plaited, and after being treated to make them rot-resistant by soaking in seawater and drying in the sun, they are used to make dwellings. The terminal bud of the coconut, known as the cabbage, can be eaten. Finally, coconut palm wood is used for building, but not before the sap is extracted to make syrup, sugar or a fermented beverage.

Cocotier

QUINCE TREE
Family **Rosaceae**
Genus *Cydonia*

The botanical name of this shrub, *Cydonia*, comes from the ancient city of Kydonia or Cydonia on the island of Crete. But its common name is derived from the Latin *cotoneum malum*, 'downy apple'. The quince is quite a strange fruit. The pear-shaped fruit is acid green in colour before turning bright yellow in autumn, announcing that it is ripe. However, the thick skin retains its covering of white down, and even ripe quinces are hard enough to put the best knives to the test. So, think twice before biting into a raw fruit! The flesh is terribly sour. The exquisite flavour of quince is only discovered when cooked as compotes, jams or jellies. This fruit also adds an incomparable aroma to sweet and savoury dishes, such as tagine. A single quince of the giant Vranja variety can weigh up to two kilograms. The Romans, who brought the tree back with them from Central Asia, recommended its eating. While it is practically ubiquitous, even growing wild, the quince tree has little to offer, aside from its fruits and the beauty of its glossy foliage and masses of pinkish-white blooms. This shrub rarely grows to a great height, and its trunk is not thick enough to allow its wood to be used in carpentry. However, its hardiness means it is often chosen as a rootstock for pears.

Cognassier

SERVICE TREE
Family **Rosaceae**
Genus *Sorbus*

———————

Who knows what a sorb apple is? This fruit of the service tree, also known as the sorb tree, was highly sought-after until the eighteenth century. Shaped like tiny pears, sorb apples are picked in late autumn, when they have turned a yellow-brown colour. They would traditionally be dried, then ground and incorporated into a dough to make a nourishing bread that was prized when food was scarce. They were also fermented to make a cider-like beverage, known in France as *piquette de cormes*. The French name for the sorbus apple, *corme*, comes from that of a beverage made by the Gauls, *curmi*. The reddish wood of the service tree also enjoys an excellent reputation. Being one of the hardest woods taken from French forests, it was used to make screws for use in different machines (such as windmills), handles for tools, rulers, seats and rifle butts. This native of southern Europe is now almost never cultivated. Service trees endure in the wild, particularly in the southern part of France, where they grow beside young oak trees, at the foot of which truffles are found. The relative of the service tree, the rowan, is more commonly found in gardens. The clusters of dark red rowan berries adorn the trees until the winter. Like sorb apples, rowan berries are not eaten raw. They are used to make jams, brandy and liqueurs.

———————

Cormier

DOGWOOD
Family **Cornaceae**
Genus ***Cornus***

The dogwood has the hardness of horn, as indicated by its Latin name, *cornus*. The genus includes many species of trees and shrubs. Some of these, introduced into Europe from North America and Asia in the seventeenth century, continue to be popular as ornamentals in gardens owing to their abundant flowers, which are mostly yellow. The Cornelian cherry tree and the common dogwood are species typically found in the eastern Mediterranean region. They grow practically everywhere in France at low altitude, except in the west, where they are less suited to the wetter climate. The very hard wood of the different dogwood species was highly prized in ancient times for the shafts of lances and throwing spears, and later to make rifle butts. More peaceful uses were ladder treads and musical instruments. The fruits of the common dogwood were once used to produce oil for lamps and soap. But only the Cornelian cherry tree was given a place in orchards. Its beautiful currant-red fruits, Cornelian cherries, ripen at the end of summer. They have a tart and slightly bitter flavour. They were once used to make jellies, syrups and highly popular fermented beverages. The picking of Cornelian cherries has practically died out as a tradition in the French countryside. This practice endures in eastern Europe and the Middle East, where this tree is still grown for its fruits.

TONIQUE

Cornouiller

CYPRESS
Family **Cupressaceae**
Genus *Cupressus*

In ancient Greek mythology, the cypress was the tree of Hades, the god of the dead. It symbolized immortality, given its great longevity (five hundred years), evergreen foliage and durable wood, which was famed for being resistant to decay. It was used to make the coffins of soldiers who died in war, and later those of the popes. The Chinese would consume its seeds in the form of an elixir for long life. Cypress resin gives off a smell resembling that of frankincense, which adds to the mystery of this tree. *Cupressus sempervirens* ('evergreen') is a species that originated in Asia Minor. It spread throughout the Mediterranean region a long enough time ago for the ancient Greeks to have named it *kypárissos*, meaning 'which comes from Cyprus'. This is the Mediterranean cypress, easily recognized by its slender silhouette, which is traditionally found growing in cemeteries in the south of France. Its association with death has somewhat limited its use as an ornamental tree, despite its graceful stature and the ease with which it is grown. The ancient Greeks, however, also associated it with love. Eros's arrows were made of cypress wood. A more mundane use of the cypress is its use in windbreaks to protect vegetable crops. Its wood was also used for building and objects made by turning on a lathe.

Cyprès

LABURNUM
Family **Fabaceae**
Genus *Laburnum*

In early May, the abundant clusters of golden yellow laburnum flowers, which hang from thin branches giving off a sweet and subtle scent, are tempting to pick. But beware; the leaves, flowers and seeds are extremely toxic, even deadly! This tree of modest stature belongs to the broom family, which is so numerous that it had to be divided into several genera. The genus *Laburnum*, to which it belongs, contains only three species. The common laburnum, for example, is so common throughout western Europe that would pass for a native. However, it originated on the Cycladic island of Kythnos, from which its French name, *cytise*, is derived. The name laburnum is derived from the Latin *alburnum*, meaning 'white wood'. It has also been given the ironic name of 'false ebony' because its wood is as light and soft as that of ebony is dark and hard. The common laburnum grows in southern Europe to an altitude of 1,800 metres, from the east of France to Romania. The flexibility of its branches meant it was used for making bows. Its wood was also used to make the handles for tools and barrel rings. It is one of the rare species that is suited to chalky soils, and the fact that it requires little more than light to thrive makes it suitable for reforestation.

Cytise

DATTIER
Family **Arecaceae** or **Palmaceae**
Genus *Phoenix*

———————

The image of a languid Cleopatra being fanned by a slave waving a large date frond is actually quite plausible. In India, where this tree is believed to have originated, and in Mesopotamia and Egypt, the date palm was cultivated five thousand years ago. At that time, a method had already been found to optimize pollination by inserting male flower spathes into the middle of the flower spathes on female trees, a technique that is still in use. Date palms love heat, sunlight and extremely dry climates, and are at home in the Sahara, on the Arabian Peninsula, and in the deserts of Iraq, Iran and Pakistan. It can grow on the Mediterranean coast of France, but its fruits do not ripen north of Andalusia, Spain. Energy-filled dates are eaten fresh or dried. They can also be made into a fermented beverage. The gifts offered by this tree are not limited to its fruits. The wood of the date palm burns well. It can also be used for building and carpentry, and for making kitchen utensils. The fronds are woven and used as roofing or to consolidate sand dunes. The thorns of the date palm are made into pins and used by weavers. Sap is also extracted from its trunk to be made into palm wine. Such generosity could only be met with gratitude. The branches of date palm were used to signify victory in ancient times. Palm branches (symbolic ones, in this case) are still awarded in France as a symbol of honour.

———————

Dattier

DRAGON TREE
Family **Liliaceae**
Genus *Dracaena*

The dragon tree owes its name to the substance extracted from its trunk. This resin, which dries in contact with the air, is known as dragon's blood because of its dark red colour. The ancient Greeks, Romans and Chinese were familiar with its medicinal properties. They were already using it to make dye. When dried and ground into a powder, dragon's blood gives a pigment that has been used to make varnishes and inks. And because it burns very easily, it has also been used as incense. It was considered to have exceptional powers, including keeping the forces of evil at bay and bringing back a lost love. Two species of dragon tree produce dragon's blood: the Socotra dragon tree, a remarkable parasol-shaped tree that is endemic to the island of Socotra, Yemen; and the Canary Islands dragon tree, which is also found on the islands of Madeira and Cape Verde, and in the High Atlas Mountains. The Madagascar dragon tree, which does not produce dragon's blood, is very well known in our part of the world. Under the name of dracena, it is one of the most popular house plants. Like its larger cousins, it loses its leaves as it grows, leaving a pretty tuft of leaves at the end of a long, thin and bare trunk. Certain varieties of dragon tree are valued for their effectiveness at removing pollution.

Dragonnier

SANG DRAGON

EBONY TREE
Family **Ebenaceae**
Genus ***Diospyros***

The fame of this tree, native to tropical and subtropical regions, is due to its black wood, which is heavier than water, hard and resistant, whose fine grain creates a beautiful finish when polished. Musical instrument makers and sculptors adore the wood of this tree, ebony. It is used to make piano keys, clarinets, chess pieces, knife handles and jewellery boxes, among other things. Europeans considered ebony to be particularly precious in the Middle Ages. In the seventeenth century, a way was found to cut it into very thin sheets, which made it prized for use in marquetry. This art of inlay, practised by the ancient Egyptians and reaching new heights in Italy during the Renaissance, then began a golden age lasting two centuries. At that time, the artisans specializing in this precision work became known as ebonists. However, only a few species of ebony tree serve for marquetry. *Diospyros ebenum*, the true ebony or Ceylon ebony tree, is sought after because its wood has an almost invisible grain. It grows in southern India and Sri Lanka. It is a protected species and its export is heavily restricted. *Diospyros melanoxylon*, from southern India, is known as Coromandel ebony. Its wood is distinguished by its purple hue. *Diospyros perrieri*, growing in Madagascar and Mauritius, shares the market with an African species, *Diospyros crassiflora*, whose wood is less dark, at times with white veins.

Ebénier

COMMON BARBERRY
Family **Berberidaceae**
Genus *Berberis*

The pale red barberries borne by this tree are covered with an opaque bloom. They ripen in September, like the grape, and were once used to make a fermented beverage, known as barberry – a custom that endures in the Nordic countries where grapes cannot be grown. These tart berries were also used to make syrups, jellies and jams. They were used in Dijon to flavour lozenges. While still green, they would be pickled in vinegar and used in place of capers. The roots, wood and bark of the tree were used to make dyes. The common barberry was also planted in hedges around enclosures, because its thorns made a particularly effective deterrent. However, it is no longer used for these purposes in France because laws were passed in the early twentieth century banning the growing of this highly decorative shrub. What was the common barberry's crime? It served as a host for black stem rust, a disease caused by a fungus that is particularly deadly for cereal crops. While it has not fully disappeared, it is only found in places far away from farming areas. This is a pity, as its berries are high in vitamin C and stimulate liver and kidney function. There is another curious feature to the barberry: slightly touching its flower stamens causes them to stand on end and then curl up. Unwitting insects instantly find themselves covered in pollen, which is a good thing because it ensures pollination of the tree.

Epine Vinette

WHITE SPRUCE
Family **Pinaceae**
Genus *Picea*

The coniferous spruce is called *épinette* or *prusse* in the French-speaking parts of Canada and is known as *épicéa* in France. The genus *Picea* prides itself on having among its very numerous members what is thought to be the oldest tree in the world, an 8,000-year-old Norway spruce. Its name comes from the Latin word *pix*, 'pitch', in reference to its resin. There are about 50 species in the genus *Picea*. Among them, the white spruce is distinguished by its modest size – but it nevertheless grows up to 25 metres! The colour of its needles earned it the Latin name *Picea glauca*, 'bluish-green'. Attempts to plant the white spruce in Europe as early as the eighteenth century have not been very convincing. In North America, however, this squat, pyramidal tree with elongated pine cones occupies an extremely vast territory, from the Atlantic to the Pacific, and from Alaska to the Great Lakes region of the northern United States. Its sturdy wood is appreciated for construction and boat building. It is also used as pulp for making paper. While it is overlooked for fine carpentry work, it is happily used to make simple furniture and tool handles, particularly for the axes that were once used to cut them down.

Epinette bl. du Canada

MAPLE
Family **Aceraceae**
Genus *Acer*

———

The most famous tree of the very numerous species comprising the genus *Acer* is *Acer saccharum*, the sugar maple. The leaf of this tree, with pretty serrated leaves that turn a blazing red in autumn, adorns the Canadian flag. The natives of North America have long consumed the delicious sap of the sugar maple, maple syrup. According to one of their legends, a squirrel drew attention of humans to this treasure. However, this discovery is also attributed to Nokomis, the Earth goddess. There were five native species of maple that had been growing for thousands of years in Europe before new species were imported from North America and Asia in the eighteenth century. These inhabited mountainous areas and the regions surrounding the Mediterranean. The ancient Greeks dedicated the maple tree to Phobos, the god of fear. Homer tells of how the army led by Odysseus chose maple wood for the construction of the Trojan Horse. The Romans made their lances and spears in maple. The wood of this tree was later reserved for more refined work: in musical-instrument making, the rippled grain of maple wood has acoustic qualities, and violins and guitars are adorned by its elegant alternation of light and dark lines; burr maple, wood taken from a growth on the trunk of the tree, is used in cabinet-making; maple is shaped on a lathe into the handles of tools; and the sturdiness of maple makes excellent flooring.

———

Erable

ASH
Family **Oleaceae**
Genus *Fraxinus*

In Greek mythology, the ash was the tree of Poseidon, god of the sea, storms and earthquakes. Lone ash trees attract lightning, *fraxinus* in Latin, which is its botanical name. However, if Slavic lore is to be believed, one can rest easy in the shade of an ash because it repels snakes. The Germanic and Scandinavian peoples called it Yggdrasil. They believed the world was created around this tree, because it was connected by its tip to the realm of the gods, and by its roots to the realm of the dead. When the end of the world came, only Yggdrasil would survive and give birth to a new creation. Druids used to carve their wands from an ash branch. That was why the first Christians in Celtic lands would burn great numbers of these sacred trees. But it would take much more to eradicate this mighty tree. The great stature of this tree is awe-inspiring, while its light green foliage is pleasing to the eye until it falls in the autumn. The genus *Fraxinus* comprises more than 60 species, which grow throughout the northern Hemisphere. The ash has been used for many things: its bark reduces fever and was once used for tanning leather; its fruits were used to make a refreshing and anti-rheumatic beverage known as *frenette*; its leaves were fed to animals; its hard, compact and solid wood was used to make wheels and carriages, tool handles, boat rudders and skis, among other things. However, the ash has a flaw: its invasive roots expand outwards to the detriment of neighbouring trees.

Frêne

SPINDLE
Family **Celastraceae**
Genus *Euonymus*

The genus *Euonymus*, of which the European spindle tree is a member, comprises some 120 different species from around the world. Its strange name is derived from the ancient Greek *euônumos*, a term meaning 'aptly named' or 'auspicious', which may have been used ironically, given that it has nothing good to announce. Instead, its small, pretty red fruits with orange seeds are toxic. Advantage was taken of this toxicity by drying the fruits and making them into a pesticide. Despite its poisonous nature, this fast-growing shrub with a modest life span is used for hedges whose lightness makes them very attractive. It is known by the nickname of bishop's hat, a reference to the shape of its fruits. The wood of the spindle tree, which is yellowish in colour and brittle, was nevertheless prized by musical instrument makers and turners, who turned it into, among others, spindles for spinning wool, from which its name is derived. The French name for the tree, *fusain*, is derived from the Latin word for spindles, *fusi*. However, the word *fusain* in French has also come to signify a drawing implement particularly suitable for sketching, which has been adopted by many great artists over the centuries and is also made from this tree: charcoal. Sticks of charcoal are made by burning young tree branches in a kiln. They are typically made from willow wood nowadays. Competition from new chalks and leads has never dethroned natural charcoal, which has retained its prominence.

Fusain

LIGNUM VITAE
Family **Zygophyllaceae**
Genus *Guaiacum*

Before the Spaniards colonized Colombia, the only country in South America with both a Pacific and Atlantic coast, the land was ruled by the Muisca people. One of their myths explains that at the dawn of time, the Earth was borne by four lignum vitae trees that were so steadfast that they kept the earth from shaking. Alas, a treacherous god, who was much less sturdy than the trees, was punished by having to take their place, the reason our planet has suffered from earthquakes ever since. This tree, also known as the guayacan, is native to the northern part of South America, the Antilles and the island of Hispaniola. Its very hard, greenish-brown wood is suited to turning on a lathe and was used to make pulleys, axles, screws, tool handles and casters for furniture. Its bright green, evergreen leaves and blue, star-shaped flowers that give way to small, heart-shaped fruits have made this tree a prized ornamental – except in Europe, sadly, as conditions are unsuitable. The medicinal properties of lignum vitae brought it fame across the oceans. Both its resin and wood in decoction were used in preparations to induce sweating and aphrodisiacs, and in remedies for arthritis and syphilis. It was also used in elixirs to extend life, hence its name, meaning 'wood of life'. It is still used in the pharmaceutical and perfume industries today. Because of over-exploitation to the point of extinction, this beautiful tree now enjoys official international protection.

Gaïac

GOMMIER
Family **Burseraceae**
Genus *Dacryodes*

This tree gave its name to the canoes carved out of its trunk by the native inhabitants of the Caribbean. Until the mid-twentieth century, gommier or 'gum tree' boats were mainly used for fishing in Martinique and Guadeloupe. They are only seen today fitted with a sail in regattas that are quite popular with locals and tourists alike. The very hard-wearing wood of the gommier tree is highly suited to boat building, although its hardness makes it almost useless for carpentry work. Its pale yellow, aromatic and flammable sap is used as incense and to make skin-healing poultices. The French name for this tree, *gommier blanc* ('white gum tree') is shared with trees from different families, including the gum arabic tree, from which gum arabic is extracted for use in the pharmaceutical, cosmetic, food and textile industries; and *Eucalyptus viminalis*, the ribbon gum, a giant Australian eucalyptus tree whose sweet sap provides a feast for marsupials. The French word *gommier* actually refers to any tree that produces gum, all of which are native to tropical regions. Also known as 'gum trees' are the eucalyptus, among which two species particularly stand out: the blue gum, from which a strongly aromatic and antiseptic oil is produced for treating respiratory ailments; and the red gum, whose beautiful shiny wood must be dried for a long time before use. *Gommier* is also used to refer to *Ficus elastica*, famous in the living rooms of the world as the rubber tree.

Gommier blanc

POMEGRANATE TREE
Family **Punicaceae**
Genus *Punica*

The Romans named the fruit of this tree *malum granatum*, meaning 'apple with many seeds'. The English pomegranate, is derived from the Old French translation of the Latin. The large number of seeds it contains made it a symbol of fertility. Patience is needed to eat a pomegranate. First its tough peel must be cut open, the pink grains it contains are removed one by one, their tangy juice sucked, and the seeds finally spat out. The pomegranate tree originated in Central Asia, from the shores of the Caspian Sea to Afghanistan. It was spread by travellers, some towards the west and to the north and south shores of the Mediterranean, and others towards India and southern China. Wherever it went, it became one of the most prized shrubs. However, it was impossible to take it further north because it only likes hot climates. Its beautiful and pleasantly lasting scarlet blooms made it a feature of sun-filled gardens, those of King Solomon seemingly among them. While the pomegranate is not a very decorative fruit, and despite the efforts required to eat it, its qualities were already known in ancient times. The juice from its grains was used as a dye and is still made into a refreshing beverage. True grenadine syrup is only made from pomegranates. The tannin-rich bark from the branches of the pomegranate tree is still used for tanning leather in North Africa. Once boiled, the bark of its roots was used as a cure for intestinal worms until very recently.

Grenadier

BEECH
Family **Fagaceae** or **Cupuliferae**
Genus *Fagus*

This tree was once used to make the typical peasant footwear, the clog. This European tree, a lover of loose soils and temperate climate, will not cross the borders of Sweden or of Russia, although it has forayed into the southern part of Central Asia. The common beech, *Fagus sylvatica*, accounts for ten per cent of the forest trees in France. It is present throughout the country, except in Aquitaine and the Mediterranean region. In mountainous areas, it shares space with conifers. In the most beautiful beech groves, found in Picardy and Normandy, there are specimens up to two hundred years old. The Latin scientific name *Fagus* is the origin of the French words *fouet*, whip or riding crop (originally a beech stick) and *fouine*, the beech marten, which makes its home in this tree. However, the common name for the tree, *hêtre*, is of Germanic origin. The beech has a long association with the book. The Norse peoples of Scandinavia in the third century used its bark to carve out the runes of their alphabet and called the tree *boeki*, from which the English 'book', German *buch*, and French *bouquin* are derived. Its wood was later used as pulp for making paper. Beech wood is easy to work, serving for fine carpentry, but it has one weakness: if left in the open, it will rot. Nevertheless, the remedy for this flaw comes from the tree itself. It is protected by coating it with creosote, a viscous liquid obtained by heating the wood to a very high temperature.

Hêtre

HOLLY
Family **Aquifoliaceae**
Genus *Ilex*

The between two and three hundred species in this genus abound in Latin America. *Ilex paraguayensis*, commonly known as yerba mate, grows in Paraguay, Brazil and Argentina. Its caffeine-containing leaves are made into an infusion, called mate or maté, a stimulating tonic drunk through a straw. There is only one native European species, the common holly, which is ideal for hedges. The French word for holly, *houx*, is derived from the Frankish (the now extinct language of the Franks) *hûliz*, which gave rise to the word *houspiger* in Old French, literally 'to comb with a holly branch', later becoming *houspiller*, 'to scold'. Naturally, the leaves of this shrub, which bristle with sharp spines, are more suited to sweeping, their former use, than to a show of endearment. Because the holly tree bears fruit in winter, it was a symbol in ancient times of life's endurance. Holly figured prominently in the Roman festival of Saturnalia, an occasion for great celebration held in January to commemorate the Golden Age, when Saturn ruled the world with peace and harmony. The Germanic peoples adorned their homes with holly branches to honour the spirits of the forest. From this comes the custom of decorating homes with holly at Christmas time. However, you must resist the temptation to eat its pretty red berries because they have a very strong laxative effect.

Houx

YEW
Family **Taxaceae**
Genus *Taxus*

Yew wood fibres were once used to make clothes. From this long-gone craft the name of the tree remains, derived from the Celtic *ivin* or from the Greek *huphê*, both meaning 'cloth'. The scientific name for yew, *Taxus*, is derived from the Greek *taxis* (order, arrangement), in reference to the regular arrangement of the leaves on its branches in rows. The Latin word *taxicum* means 'poison', which was the use made by the Romans of the leaves of the yew, hence its nefarious reputation. The Celts, whose druids considered the yew sacred, made spears and shields from the its wood. They also took advantage of the poisonous fruits for use in hunting and warfare. The shade of the yew was believed to be equally dangerous, particularly in spring, when it bears its small, round and yellow catkins. As a result, this tree was considered sacred to the deities associated with death in ancient times. The Romans dedicated it to Hecate, goddess and guardian of the underworld. The old custom of planting yew trees in cemeteries has been preserved because its poisonous nature serves to dissuade livestock from straying into these places of contemplation. Because the yew can bear being clipped into the most complex topiary shapes, it still has a very special place in French-style gardens. The use of the taxine contained in its leaves as an antispasmodic medication has ceased, but this product continues to be used in cancer drugs. Yew leaf extract is used in homeopathy.

BAY TREE
Family **Lauraceae**
Genus *Laurus*

———————

Laurier is the French name for two trees that should never be confused. One, commonly called the *laurier-sauce*, is the bay tree, whose leaves are used in cooking for their strong aromatic flavour. The other, the *laurier-rose*, is the oleander, a pretty shrub with masses of lasting flowers that is popular around the Mediterranean, but whose leaves are highly toxic. The bay tree has several other names. It is especially known as the laurel, a reference to a tragedy involving the Greek and Roman god of music and poetry, Apollo, and this tree. After slaying the serpent Python with his arrows, Apollo boasted of this to Eros. The annoyed god of love shot him with a golden arrow, causing him to fall madly in love with the nymph Daphne. But she refused him and ran away as fast as she could. Apollo chased her until she could go no further. She then begged for help from her father Peneus, the river god, who turned his daughter into a laurel tree. Apollo was stricken with remorse and made the laurel his sacred tree, which became associated with his cult. Pythia, the oracle of his temple at Delphi, would chew bay leaves to better receive the god's messages. First a symbol of peace, the tree would later signify victory in battle. In the Middle Ages, praise-worthy people were crowned with laurel wreaths. This gave rise to the term laureate ('crowned with laurels') for winners of distinguished awards. The leaves adorned with berries, *bacca* in Latin, gave rise to the term *baccalaureate*.

———————

Laurier

MANCHINEEL
Family **Euphorbiacées**
Genus *Hippomane*

The loggers who fell this tree in equatorial regions need to exercise great caution and skill, because the sap, flowers, fruits and even the sawdust are highly toxic. In Guadeloupe, signs warn visitors venturing into the forest of the dangers of the manchineel tree. Above all, its fruits, which resemble lemon-scented apples, must not be eaten. And it is unwise to take shelter from the rain under its leaves, because any sap dripping from the tree can cause serious burns. There are no longer hunters and warriors waiting in ambush, the tips of their arrows dipped in manchineel sap. The milky liquid provides a natural poison. A magnificent sight with its large, bright green leaves, this tree was once planted in hedges along coasts. It made an excellent barrier against intruders such as cactus. The manchineel tree is highly suited to sandy soils. It is used to strengthen sand dunes on the beaches of Florida and Central and South America, and is often found in the Antilles. The beauty of the grain of manchineel wood is another of its qualities, and it is prized for cabinet-making. Given that the dangers and benefits of this tree are balanced, loggers have found a way to counter the former. They light a big fire around the selected tree, and as the heat hardens the sap, it can no longer flow.

Mancenillier

HORSE CHESTNUT
Family **Hippocastanaceae**
Genus *Aesculus*

The horse chestnut or conker tree, a tree that grows straight and strong in our parks, school playgrounds and along avenues, is known in French as the *marronier*, or *marronier de l'Inde* ('Indian horse chestnut'). Despite this name, it is actually native to the temperate rainforests of the Balkans, where it survived the Ice Age. This error dates from the time of its arrival in France in 1612, when India was seen as the origin of anything new and exotic. The horse chestnut came to western Europe via Constantinople. The first plant was brought to Paris by the botanist Bachelier in the seventeenth century, and it lived until 1840 in the courtyard of the Hôtel de Soubise, a mansion in the Marais district. The edible nut we know as the chestnut comes from the sweet chestnut tree. The fruit of the horse chestnut, a capsule covered with spikes, contains a bitter nut, called a conker, formerly given as a treat to livestock. Conkers are used to produce starch and a paste used by bookbinders. They are also used in the pharmaceutical industry as ingredients in treatments against venous insufficiency, and in the cosmetics industry to make sun creams. Elderly men still carry a conker in their trouser pockets to prevent rheumatism. In the jargon of French journalism, a *marronnier* or 'horse chestnut' is used for a topic that is evergreen or of recurring relevance, evoking the dead horse chestnut leaves that invariably cover schoolyards after classes resume in the autumn.

Marronnier

LARCH
Family **Pinaceae**
Genus *Larix*

Among the trees that inhabit our forests, *Larix decidua*, the European larch, is the only conifer that loses its leaves in winter. This species is native to the Alps and the Carpathian Mountains and is common throughout Europe. It colonizes any place with plenty of sunlight and well-watered soil, but with not too much atmospheric humidity. Its legendary hardiness is only outmatched by pollution, which is why larches are not found in cities. Larch is used for reforesting mountainous areas, where it is in its element. Even in places where larch forests are not naturally found, it is at home. It grows quickly and can live as long as six hundred years. However, the larch plantations that were established on the plains in the 1950s experienced great difficulties. In spite of this, forestry managers persevered, encouraged by the prospect of producing abundant, high-quality timber, and achieved success. Larch wood has for centuries been prized for building and carpentry work. The logs used to build traditional mountain chalets are larch. Larch wood was proven to be so resistant to rain that gutters and structural frames were made from it. Moreover, it is also easy to work, making it suitable for picture frames. Larch resin is collected and distilled to produce turpentine, known as Venice or Briançon turpentine, and it is also used in the pharmaceutical industry and in medical research.

Mélèze

WILD CHERRY TREE
Family **Rosaceae**
Genus **_Prunus_**

The name of the wild cherry tree in French, _merisier_, comes from the Latin _amarus cerasus_, 'bitter cherry'. Wild cherries are known in French as _guignes_ or _griottes_ (a general term for sour cherries) as they are quite sour; they can barely be eaten raw. Where wild cherry trees are plentiful, such as in the Vosges and Alsace regions of France, the fruits are made into jams and a brandy known as kirsch, which is the German word for cherry. Wild cherries are used as ingredients for certain bitter liqueurs. Merisette, a liqueur from the Grenoble region, is made using crushed wild cherry seeds and flavoured with spices and fresh peach leaves. A decoction of wild cherry stems makes a diuretic beverage. This sturdy tree is used as a rootstock for all species of sweet cherries. One particular use given to its wood is the manufacture of tobacco pipes and walking sticks. It is very highly prized in cabinet-making, although much patience is needed to work the wood. Unless it is artificially dried out in a drying oven, it will take between two and three years before it is ready to work with. After this long period, wild cherry wood turns a reddish-brown colour similar to that of mahogany. Despite its benefits and its ability to spread naturally, the wild cherry tree was considered evil. Germanic peoples once believed that demons found shelter in them. To chase them away, there was but one solution: to burn the branches at new year.

Merisier

NETTLE TREE
Family **Ulmaceae**
Genus **Celtis**

Of the 70 species of nettle tree, the one that has grown in the Mediterranean region since prehistoric times is *Celtis australis*, the European nettle tree. It is also known as the Mediterranean hackberry. The inhabitants of southern France have given this tree a large number of melodious names: *falabreguier* and *brigolier* in Provence; *balicoquier, fanabregon, fatelier, paparotier, petier* and *pitapolier* in Languedoc; *pergulu* and *sciarabulu* in Corsica; *lledoner* in Catalan-speaking areas ... and *bois de Perpignan*, 'Perpignan wood', in most places because the fame of the nettle-tree-wood whip handles produced in this town had spread beyond the borders of the Pyrénées-Orientales region. How did the nettle tree earn such popularity? One particular reason was that the tree naturally produces trifurcate (three-pronged) branches. In the Gard region, by skilfully controlling the growth of the branches, pitchforks are formed on the actual tree and are ready to be sawn off when they reach a suitable thickness. The flexible but strong wood of the nettle tree is also suitable for walking sticks, tool handles, wind instruments and oars, among others. The yellow bark of the nettle tree is used to make dye. Hackberries, as the edible, purplish-black fruits of this tree are known, are about the size of a pea and have a sickly sweet taste. They ripen in autumn. An oil of similar density to almond oil was once extracted from their seeds and used in oil lamps.

Mtcocoulier

MULBERRY TREE
Family **Moraceae**
Genus *Morus*

The French word for the mulberry tree, *mûrier*, is shared with a wild forest shrub with similar fruits, the blackberry, although they have nothing else in common. The mulberry tree has a sturdy trunk of dense wood and grows to between 10 and 15 metres tall. Among the species introduced into France, *Morus alba* – the white mulberry, on account of the colour of its fruits – once brought great wealth. The Chinese owed their ability to keep the coveted monopoly on silk until the sixth century to the leaves of the white mulberry tree, on which silkworms, the larvae of the silkmoth, gorge themselves. The tree crossed the borders of its native China with missionaries, who took their precious cargo to Constantinople. It would take almost one thousand years before it arrived, by way of Italy, in southern France, where silk farming and production developed in the sixteenth century. At that time, the black mulberry tree was supplanted by the white mulberry because the silkworms that were fed on the leaves of the former produced a silk of lower quality. Originating in Central Asia and brought into Europe in ancient times, the black mulberry tree was cultivated for its deep purple berries, which were used to make wine and syrups to soothe sore throats and mouth ulcers. The kagaya or plane-tree-leaved mulberry does not bear fruit and is instead trained for arbours. This tree has large green leaves, providing welcome shade in the squares of southern France.

Mûrier

NUTMEG TREE
Family **Myristicaceae**
Genus *Myristica*

This tree is native to the Banda Islands, in the Maluku (Moluccas) archipelago of Indonesia. Nutmeg has been known and prized in Europe since the Middle Ages. The Arabs controlled trade in this spice until the fifteenth century, when the Europeans managed to break their stranglehold on trade in products from Asia. A fierce rivalry ensued between the Portuguese and the Dutch, who emerged victorious. Nutmeg tree saplings were then taken to the Antilles, where they became well acclimatized up to an altitude of five hundred metres. The light, unscented wood is suitable for making small items of furniture. But it is the fruit that gives this tree so much value. The round, pale yellow fruit, streaked with red and green markings, is reminiscent of an apricot. When ripe, its white flesh is cut open to reveal a scarlet kernel, which is enveloped in a woody membrane known as an aril. After drying in the sun for two weeks and then being ground to a powder, the aril becomes mace, a peppery spice with a pretty orange colour that is widely used for making cured pork products. After drying for another several weeks, the kernel shell is broken to release the seed, nutmeg, which is immediately soaked in lime juice and blanched with lime to protect it from parasites. The less presentable specimens will be made into oil for use in the perfume and food processing industries. Fragrant nutmeg is a narcotic if used in large quantities, with dangerous effects.

Muscadier.

WALNUT TREE
Family **Juglandaceae**
Genus *Juglans*

Juglans regia, the common or English walnut tree, is the only tree in this family capable of reproducing spontaneously in France. It is typically planted on its own or with others of its kind because the juglone (natural aroma) contained in its leaves and roots repels other species. You are therefore advised not to stand under the shade of a walnut tree, unless you are a witch. In the Middle Ages, it was actually thought that witches would typically hold their covens at the foot of this large and wide tree, where they were safe from divine wrath, because walnut trees did not attract lightning. A native of Asia, the walnut tree travelled with the Persians to Greece, and then to Italy. The Romans believed it to be the tree of Persephone, the goddess of the underworld. In France, however, signs of its presence have been found dating from prehistoric times in the Périgord region, which remains its heartland. The walnut tree grows very quickly, but only produces flowers and fruits in its fifteenth year. Walnuts are picked either while still green, in June, or ripe, in autumn. It is better to wear gloves for this because the husk encasing the nuts stain the skin. The husk is removed from the nut and used to make dye. The actual nuts, referred to as walnut kernels, are eaten fresh or dried. They are pressed to make an oil that is only used raw and can only be kept for a short time away from light. Walnut wood has been beloved by carpenters and sculptors for its warm-coloured veining.

Noyer

Huile

OLIVE TREE
Family **Oleaceae**
Genus **Olea**

There is no doubt that the first olive trees grew in Egypt. They were introduced into Greece, from where they spread as far as Arabia and the Crimea, Italy and Provence. Wherever it was found, this tree of modest size, with its twisted and knotted trunk that is at home in stony soils, showed that by growing slowly, it could live to a very old age. It was prized for its fruits that give an oil that is not only nutritious and flavourful, and wonderful for massages to relax the muscles, but also beneficial for treating ailments. Olives are picked green in autumn or black when fully ripe in deep winter, but they are inedible raw. They require treatment to rid them of the terribly bitter compound they contain, oleuropein, before being preserved in oil or salt. These preparations have been a part of Mediterranean culture since ancient times, as has the tradition of carving everyday items from olive wood. The tree was revered. The dove released by Noah to announce the end of the Great Flood brought back an olive branch – and this bird became a symbol of peace. Olive branches were made into wreaths and crowned the victors at the Olympic games of ancient Greece. In France, olives and their derivatives have gained a huge number of fans since the 1980s, well beyond the borders of Provence. Unfortunately, devastating frosts and the expansion of wine-growing have led to a decline in olive groves, and France has become an importer of these traditional products.

Olivier

ORANGE TREE
Family **Rutaceae**
Genus *Citrus*

The scientific name of this tree, *Citrus sinensis*, attests to its Chinese origin. Arab caravans introduced it into Palestine, from where the Crusaders brought it back to Europe. Like all citrus, orange trees were only suited to the Mediterranean region or were grown in properly heated orangeries. This species is considered to be a cross between *Citrus maxima* (grapefruit tree) and *Citrus reticulata* (mandarin tree). Its fruits are known everywhere for their high content in vitamin C, concentrated sunlight in the heart of winter, and are an excellent resource for producing countries. Brazil leads the world, followed by the United States (Florida and California), Mexico, India and Spain. There is little doubt that the golden apples of the garden of the Hesperides, which in Greek mythology were under the protection of the nymphs of the evening, referred to oranges. They are known as sweet oranges, to distinguish them from the bitter oranges of *Citrus aurantium*, Seville oranges, which cannot be eaten unless cooked. The zest of these bitter fruits is an ingredient of certain liqueurs. The flowers of this tree produce an essential oil, neroli oil, named after the princess who made it fashionable as a perfume in the eighteenth century. As these flowers are too frail for conventional distillation, they undergo steam distillation. The by-products of this are orange flower water, an edible essence that is used to make perfume and as an ingredient of cakes and pastries.

Oranger

ELM
Family **Ulmaceae**
Genus *Ulmus*

There are about 18 species in this genus, all found in temperate regions of the northern Hemisphere. They grow into large trees of good height, with roots that penetrate deep into the soil and dense foliage, and they are prized as a shade tree for planting in avenues. The ancient Greeks consecrated the elm to Oneiros, the god of the night and of dreams and the nephew of Thanatos, the god of the dead. They believed that the fruits of this tree would accompany the soul of the dead towards the last judgement. The field elm is known by many different regional names in France, such as *aloum, houm, houmeau* and *hommeau*. It is also referred to as *arbre à pauvre homme* ('poor man's tree'), perhaps because charcoal was made from it, and the fact that charcoal burners would work in the forest under extremely miserable conditions. During the Middle Ages, feudal lords would mete out justice in the shade of an elm tree. In the seventeenth century, Sully, minister under French King Henry IV, encouraged the growing of elm trees, and the tree was very widespread in France until 1925. In that year, Dutch elm disease began to decimate elm trees. A fungus causes tunnels to occur inside the trunk, making a once glorious wood unsuitable for use. Hard and particularly resistant to moisture, elm wood was once preferred for construction, shipbuilding, the wheels of water mills, pulleys and pilings, such as those on which the houses of Venice are built.

Orme

MANGROVE
Family **Rhizophoraceae**

In 1934, *Sous les Palétuviers* (Under the Mangroves), a song from a hit operetta with risqué lyrics sung by Pauline Carton and René Koval, brought fame to trees that were only known in France by travellers familiar with tropical countries. This must not have been the case for the songwriter because the space under mangrove trees is occupied by their arc-shaped aerial roots, which is a very uncomfortable place for a nap. The pleasant-sounding name of mangrove is not a botanical classification. It designates several species from the genera *Avicennia*, *Bruguiera*, *Rhizophora*, *Amanoa*, *Tovomita*, *Laguncularia* and *Clusia*, among others. All these trees share a common feature of growing in mangroves, also used to describe the thick tropical forests washed by the tides, where their roots serve as stilts. Mangrove trees stabilize shorelines and promote the recovery of an ecosystem after a hurricane or tsunami. Advancing human activity on coasts is causing their gradual destruction, which is very worrying. Aside from this important ecological role, mangrove trees have little use. Their salt-saturated wood burns badly, and its use as pulp for making paper has not produced convincing results.

Palétuvier

TEINTURE NOIRE

ROSEWOOD
Family **Fabaceae**
Genus *Dalbergia*

The name of this tree is associated with exotic luxury. Indeed, the dense and very beautiful wood of the rosewood tree, with a high content in aromatic oils that give it a strong scent, has been sought after since the seventeenth century for fine carpentry work and musical instruments. In France, rosewood is given as a gift to mark the sixty-fifth wedding anniversary, which says a lot about its durability. The name rosewood is a reference to its scent. There are several species native to different regions, which can be identified by their colour. The most famous is *Dalbergia nigra*, Brazilian rosewood or Bahia rosewood, with its rich brown hue. Brazil is also home to *Dalbergia decipularis* or tulipwood, which is cream with red or salmon stripes; *Dalbergia retusa*, whose wood is called cocobolo, varies in tone from red to orange and is highly prized for making chess pieces; and *Dalbergia cearensis*, kingwood or violetwood, which is violet with black streaking. India is home to *Dalbergia sissoo* or North Indian rosewood, with bronze-hued wood called sheesham, and the more common *Dalbergia latifolia*, Indian rosewood, darker and redder in colour. Other species come from Africa, particularly Madagascar. Because the popularity of Brazilian rosewood almost led to its extinction, the commercialization of this tree is now heavily restricted. Today, xylophone keys, guitar parts and luxury furniture are made from much less expensive Indian species.

Palissandre

PALM
Family **Palmaceae** or **Arecaceae**

This family contains no fewer than 235 genera and between three and four thousand species. In the Cretaceous Period, palms spread as far as modern-day Canada and Scandinavia. Only *Chamaerops humilis*, known as the European fan palm or Mediterranean dwarf palm, survived in southern Europe and North Africa. A few species are able to survive in the temperate regions of the northern Hemisphere. All the others are found in the tropics. Their vast number disconcerted the Western naturalists of the eighteenth century, who struggled to classify them. In the nineteenth century, species from South America were imported into Europe. They were successfully grown in greenhouses and were turned into house plants. However, they also flourished outdoors on the French Riviera. Palm trees are a source of great bounty. Dates have been known in Europe since ancient times, and coconuts are the treasure of the Pacific Islands. Palm oil is extracted from the fruits of *Elaeis guineensis*, native to Guinea. Palm wine is also made from *Raphia vinifera*; sago (starch) is made from the *Copypha* and *Metroxylon* species; tagua or corozo, often referred to as vegetable ivory, comes from the *Phytelephas* species of Ecuador, whose seeds are also eaten; and rattan is made from the canes of the *Calamus rotang*. Not to mention the terminal bud, which is known as palm cabbage or, more commonly, heart of palm.

Palmier

PEACH TREE
Family **Rosaceae**
Genus *Prunus*

The peach tree is native to northern China and Mongolia. In the third millennium BC, the Chinese took meticulous care to grow, breed and improve a shrub that only bore dry and bitter fruits in the wild. They believed it to be a symbol of long life and attributed supernatural powers to it. Caravans of silk traders carried the tree to Persia, together with the apricot tree. The Greeks discovered the peach tree through the expeditions led by Alexander the Great and believed it to be native to Asia Minor. The Romans copied them, naming it *malum persicum*, the 'Persian apple'. This error endures in the scientific name of the peach tree, *Prunus persica*. Known as *pêcher* in French, its other common name, *mirecourtois*, has practically fallen out of use, as has that of *alberge*, a term for the white-fleshed clingstone peach. In the sixteenth century, the orchards of King Francis I were already home to some forty varieties. Today, more than three hundred varieties are grown in France, forty per cent of which have white flesh and the remainder yellow, including nectarines and more recent hybrids. The fruit of the hardy vineyard peach tree has red flesh. Many French cultivars have girls' names (Valentine, Manon, Amanda, etc.); some are named after precious stones (Ambre, Jade, Émeraude, Topaze, Azurite, among others); while others have inherited English names (such as Bigtop, Bigbang, Zeeglo, Spring Lady and Tastyfree).

Pêcher

Confiture

POPLAR
Family **Salicaceae**
Genus *Populus*

The Latin name for this tree, *populus*, means 'people'. This may have been because this fast-growing tree is found in great numbers in all the cold and temperate regions of the northern Hemisphere. Regardless, the origin of this word destined this tree to be declared the 'liberty tree' during the French Revolution and planted in large numbers with great pomp. The black poplar was associated with death in ancient times. In Greek mythology, the white poplar owes the colour of its leaves to Heracles (Hercules). Apparently, in his fight with Cerberus, the guardian of the underworld, the black poplar collar of the monstrous three-headed dog became wet with the hero's sweat, losing its colour. Whenever cypress trees were unavailable, poplars would be planted in cemeteries. Together with that of the elm and alder, the wood of the poplar tree was used to build gallows. But not only: because it is light in colour and weight, fibrous and easy to cut and polish, it is typically used to make packing cases and crates, matches and veneers. Among the large number of species, *Populus nigra italica*, the Lombardy popular, is identified by its elegant bearing. The European aspen, *Populus tremula* ('trembling poplar'), owes its scientific name to the fact that its leaves tremble with the slightest breeze. The flower spathes on female poplar trees produce masses of cottony seeds, which is why they are typically not planted in towns.

Peuplier

PINE
Family **Pinaceae**
Genus *Pinus*

Whether in the form of a maritime pine, Scots pine, stone pine, mountain pine, black pine, Swiss pine or Aleppo pine, this conifer accounts for 20 per cent of the forest trees in France. It is ranked the second most common tree, just behind the oak. The pine is suited to the poorest of soils, and its rapid growth makes it excellent for reforestation, to the extent that it sometimes becomes invasive. The ancient Greeks and Romans were already making use of its resin. They used it to make balms and to flavour wines that were known as *crapula*, a term that was later used to label drunkards. Sticky pine pitch was used to make candles and to seal amphorae. Turpentine, an effective solvent, and rosin, which is rubbed on dancing shoes and violin bows, is still extracted from pine trees. The high resin content of pine wood makes it highly flammable and dangerous to burn in a fireplace. However, this does not affect its ability to be transformed into pulp for making paper, or its use in building and carpentry. Viscous and black pine tar, made by dry distillation, has many uses, including caulking the hulls of ships, treating tree wounds, protecting horse hooves and flavouring liqueurs. Syrups and lozenges are made from pine buds. The stone pine, the symbol of Italy, provides a gourmet delicacy that is all the more prized because of the difficulty involved in its production: pine nuts, the seeds hidden under the scales of pine cones.

Pin résineux

PISTACHIO TREE
Family **Anacardiaceae**
Genus *Pistacia*

Pistacia vera, 'true pistachio', is the tree from which the nuts that have been enjoyed for centuries are obtained. The fruit, a drupe, contains a shell under its fine skin, which opens when ripe to release a single, light green seed the size of an olive. When it was introduced into France in the seventeenth century, it was called the *amande de Perse* ('Persian almond'). This species of pistachio tree is actually native to Central Asia, where it appeared some ten thousand years ago. The Roman emperor Aulus Vitellius introduced it into Italy in the first century, from where spread around the Mediterranean. It was taken to Mexico in the eighteenth century. Today, it is grown intensively in California, whose production is approaching that of Iran. Aside from their flavour, pistachios are high in nutrients, some of which help to reduce stress. The nut from *Pistacia lentiscus*, a close relative of *Pistacia vera*, cannot be eaten. But the resin from this shrub, known as mastic, is burnt as incense, used in varnishes and dental cement, and is an ingredient of raki, an alcoholic beverage from Turkey. Physicians in ancient times would use resin from *Pistacia terebinthus* as an antiseptic. *Pistacia sinensis*, however, is only planted for the enjoyment of its splendid autumn foliage. This tree grows to a height of 25 metres in its native China. But while its hardiness allows it to be grown in France, it only grows to the size of a shrub.

Pistachier

PLANE TREE
Family **Platanaceae**
Genus *Platanus*

This tree existed in the Cretaceous Period, before becoming extinct during the Ice Age. Two species reappeared: *Platanus occidentalis*, the now less common American sycamore; and *Platanus orientalis*, the oriental plane tree, native to Central Asia. The latter is one of the oldest cultivated species and the richest in symbolism. The ancient Greeks and Romans admired its longevity, which allowed it to grow remarkably wide (*platus* in Latin), to the extent that a banquet could be held inside some of the oldest specimens. The tree's hand-shaped leaves were considered a divine manifestation. The Cretans associated the tree with Gaea, Mother Earth, and the Carthaginians associated it with Tanit, the goddess of fertility. The bark of the plane tree, which sheds to allow better growth, was considered in ancient times to evoke the relentless renewal of life. A legendary specimen found on the Greek island of Kos is known as the 'tree of Hippocrates', who is reputed to have taught in its shade. It is more likely that the father of medicine only lived there, because the tree currently standing is only 500 years old, not 2,500 years, despite its 14-metre circumference. Regardless, the caduceus, the symbol of medicine, has two serpents entwined around a winged plane-tree staff. *Platanus orientalis* arrived in England in the sixteenth century and *Platanus occidentalis* followed a century later. A hybrid of both species is the London plane tree, which is planted in large numbers in cities.

Platane

PEAR TREE
Family **Rosaceae**
Genus *Pyrus*

The pear tree is one of those trees which, in the wild, bears fruits so bitter that they can only be used to make a fermented beverage (perry). However, through cross-breeding and care, it has produced more than a thousand cultivated varieties. It remains unclear when or where its cultivation began, as it has long been a part of human activity in all the temperate regions of the globe. Nevertheless, it would seem that the pear tree originated in Central Asia. The ancient Greeks considered it the tree of the moon, consecrated to Hera, wife of Zeus. In April, the tree's small white blossoms with purple stamens bloom in clusters, waiting for the bees to pollinate them. The beauty of its flowers is one of the benefits of the pear tree, which enjoys a remarkably long life for a fruit tree. Like all trees in the Maloideae subfamily, the pear tree bears fruits with skin and seeds, known as pomes. Pear season lasts from summer to the beginning of winter, depending on the species. Pears can be eaten in any season without the worry that they have come from cold storage. The hard wood of the pear tree is easy to work. It is used in cabinet-making, for musical instruments, carving, woodcut printmaking, and even for heating. Stained black, pear wood resembles ebony.

Poirier

APPLE TREE
Family **Rosaceae**
Genus *Malus*

Apple trees in flower herald the arrival of spring. And not only in Normandy, whose love affair with the apple began in the fifth century. Every year, when Persephone, wife of Hades, the Greek god of the underworld, returned to the Earth to announce the return of times of bounty, she would bring with her an apple. In Latin, the word *pomum* referred to all fruits, and the goddess of fruit was called Pomona. The French, preferring this word to *malum*, adopted it in the form of *pomme* to honour the queen of fruits, whose history is lost in the dawn of time. The apple tree, in common with all the fruit trees in the Rosaceae family, appears to have travelled the Silk Road from Asia Minor to southern Europe. Did it originally come from China, where it has been cultivated for three thousand years? Kazakhstan claims to be its birthplace, although no records exist to confirm or deny this. There were about a hundred varieties of apple trees in ancient times. They now count in the thousands, even if only the most productive are still cultivated. Two wild species have been used as rootstock for most of these: *Malus pumila*, the common apple tree; and *Malus sylvestris*, the European crab apple tree, whose French name *pommier paradis* ('paradise apple tree') recalls the Bible story of the forbidden fruit. The apple, a good source of energy that is high in vitamins and low in fat, is universally loved. Cross-breeding has led to the creation of sweet varieties, but it retains the acidity that is part of its charm.

Pommier

PLUM TREE
Family **Rosaceae**
Genus **_Prunus_**

The plum tree is one of the wonders of the _Prunus_ genus. Its hardiness and abundant blooms have been the delight of gardeners for centuries. The European plum tree comes from Anatolia, where it grows to an altitude of 1,300 metres. The tree we know today is most likely a cross between the blackthorn, whose small and sour fruits are made into a brandy, and the cherry plum tree, brought back to Europe by the Shah of Persia's French gardener in the nineteenth century. The plum tree was cultivated and improved in ancient times, particularly in what is modern-day Syria. Exquisite Damascene plums were considered a delicacy by the Romans. The tree was brought back to the West by the Crusaders. This is the origin of the French expression _pour des prunes_, literally 'for plums' and meaning 'to do something for nothing', because their expeditions would eventually turn out bring them little benefit. Among the prized varieties was the greengage, known as the Reine Claude plum in France in honour of the wife of King Francis I, who grew it in her gardens at Blois. The small, golden mirabelle plum takes its name from the Italian _mira bella_, 'beautiful to look at'. The Japanese plum, actually native to China, has also been used as a base for many hybrids. It bears very round fruits with pinkish-yellow flesh, and it accounts for a large proportion of the fresh plums consumed in France. It is used in Asia to make a sweet and salty snack with a very tart flavour.

Prunier

PERUVIAN BARK
Family **Rubiaceae**
Genus *Cinchona*

The name given to this tree, also known as the cinchona tree, by the natives of Peru was *kina-kina*, meaning 'bark of the barks'. They had already identified the benefits of this evergreen shrub typical of the forests of the Andes Mountains. Settlers in the region in the seventeenth century discovered that the bark of this tree was effective against fever. Jesuits from Lima took it to Rome. The powdered bark quickly became popular in Europe, where became known as 'Jesuits' bark' and 'Jesuits' powder'. From their empirical observations, two French chemists decided to analyse the bark in the early nineteenth century. They isolated the active compound, quinine, and then worked to extract it from the bark. They did not make their fortune from the process because they made it available to all. Industrialists hastened to use and market quinine on a grand scale. The frenzy created by the riches it was likely to generate delayed research into the treatment of malaria, which quinine was able to cure. In fact, quinine reduced this fever caused by mosquitoes, which today is still the cause of a million deaths every year. Cinchona bark is terribly bitter. In order to be able to take life-saving quinine, the British in their colonies came up with the idea of mixing it with gin. The mixture of quinine and soda was known as tonic water because of its restorative qualities. The resulting cocktail was called 'gin and tonic'. Tonic water today contains very little quinine.

Quinquina

RAFFIA PALM
Family **Palmaceae** or **Arecaceae**
Genus *Raphia*

This tropical tree has only one essential requirement – moisture, both in the soil and in the air. It is perfectly suited to growing in wetlands and beside bodies of water. As a result, it has found its ideal home in Madagascar. *Raphia ruffia*, the raffia palm, is grown on this island. Like all palms, the raffia palm provides a large number of benefits. The pulp of its plentiful fruits covered in brown scales yields a pleasant-tasting fat called 'raphia butter'. The centre ribs of the fronds are used to make roofs. But the best-known and most lucrative part of the raffia palm is the piassava (fibre) obtained from its young leaves, commonly known as raffia. The Malagasy have given it many uses over the centuries, including twine, cord, mattresses, cushions, cloth and thread. Their traditional garment, the lamba, is made from raffia woven with silk. Exports of raffia products only began in about 1860. It started with demand for a relatively coarse cloth known as raffia matting, used to make sacks and for drying sugar. Shortly afterwards, the raffia twine exported to Europe found great success with gardeners and wine-growers. Exports grew until the early 1930s. The decline came mainly as a result of the shift in Madagascar from raffia production to rice-growing. Production in Madagascar is uncertain today, limited by both climatic instability and poor-quality workmanship.

Raphia

SAGOU

SANDALWOOD
Family **Santalaceae**
Genus *Santalum*

Sandalwood is synonymous with fragrance. The living tree has a wonderful aroma. And after being felled, cut up, shaped, carved, exposed to the elements, shipped over land or by sea, and changing hands time and again, its aroma remains. Evidence of this is to be found in centuries-old Indian temples, many of which were built with the wood of this tree, which for thousands of years has been used for both beauty products and the celebration of religious rites. Mention is made of sandalwood in sacred Sanskrit books and ancient Chinese manuscripts. Honour was shown to the gods by carving scented figurines of them. The essential oil and incense that is extracted from sandalwood are still used to purify body and mind, encourage meditation, instil relaxation and relieve anxiety. In short, to drive out all the negative influences that spoil spiritual harmony. The scent of sandalwood also encourages harmony in the body. The term sandalwood is used for several species that possess these qualities, but not all of them belong to the same genus. However, the quintessential sandalwood tree is *Santalum album*, Indian sandalwood. Like all coveted species whose trade is not strictly controlled, it has become endangered. This species has become rare, and therefore expensive. The perfume and aromatherapy industries have now turned to *Santalum spicatum*, grown in Australia.

Santal

FIR
Family **Pinaceae**
Genus *Abies*

The genus *Abies* contains about forty species of conifers all found in the northern Hemisphere. Only one is native to France, the silver fir, known as the *sapin des Vosges* (Vosges fir). It is also known as *pectiné*, from *pectinata*, one of its Latin names derived from *pecten*, 'comb', a reference to the arrangement of the needles around its branches. The French word for fir, *sapin*, comes from the Latin *sapa*, meaning sap. While turpentine is extracted from fir, the resin content of its wood does not hinder its use for carpentry. On the contrary, in the mountainous regions where it abounds, it is used to build chalets that are naturally insulated from the cold. Fir wood can also be used as pulp for making paper. The symbolism of protection and renewal attached to this evergreen dates back to the oldest religions of both East and West. In Germany and Austria, and in Alsace and Lorraine, the blending of pagan and Christian traditions gave rise in the sixteenth century to the decorated and lit-up Christmas tree we all know. At the time, the Catholic Church was more reluctant than Protestant churches to embracing this tradition. However, the pagan fir emerged victorious at the end of the nineteenth century. The main species used today is Nordmann fir, whose branches can bear the weight of decorations and whose needles shed little, even when the tree is cut. The environmental cost of its intensive exploitation is much lower than that of artificial Christmas trees.

Sapin

WILLOW
Family **Salicaceae**
Genus *Salix*

It would be more appropriate to name this section 'willows', as this genus comprises three hundred species differing in appearance. It includes a number of imposing trees found in our part of the world, such as the white willow and the crack willow, whose branches break off and often take root in the soil. It also includes a number of shrubs, such as the ones that provide basket-makers with their raw material: the purple willow, also known as the purple osier; the almond willow or almond-leaved willow; and the common willow or basket osier, the most commonly used variety. In terms of longevity and yearly cycles, willows also vary greatly. All willows grow happily near water in cold and temperate regions. Well-watered highland areas are ideal for them. The bark of the white willow was already being used in ancient times for remedies against fever and pain. In the early nineteenth century, a French pharmacist realized that crystals would form when decoction of the bark was prolonged, leading to the discovery of salicylic acid, the origin of aspirin. The wood of the sturdiest willow varieties flexes without breaking, making it ideal for making barrel rings. By burning the wood, willow charcoal is produced for drawing. It is also an ingredient of black powder, a type of explosive. *Salix magnifica*, a species native to China, has nothing to offer but its beauty. It is identified by its very long leaves, which in May are accompanied by catkins of similar length, creating a striking effect.

Le Saule.

WEEPING WILLOW
Family **Salicaceae**
Genus *Salix*

This tree owes its scientific name, *Salix babylonica*, to a story from the Bible. It tells of how the Jews, captives of King Nebuchadnezzar of Babylon, wept under the shade of the weeping willow. This tree is actually native to China, Korea and Japan. It arrived in Europe in 1692. A century later, it would become extraordinarily popular with the Pre-Romantics, members of an artistic movement with a taste for the mysteries and torments of the human soul. The weeping willow fitted in perfectly with the gardens of the late eighteenth century as a feature among follies such as mock ancient ruins. Bonapartists venerated it after recognizing it on engravings as shading the emperor's grave on the island of Saint Helena; they were mistaken, because the tree was actually a weeping mimosa tree. In his poem *'Le Saule'* ('The Willow'), the Romantic writer Alfred de Musset expressed his wish to have a weeping willow planted near his grave. His wish came true. Unfortunately, the compact clay soil of Père Lachaise Cemetery in Paris is not at all suitable for this tree, which needs a great deal of water. Musset's willow starves and has to be replaced regularly. The weeping willow remains the quintessential tree to plant beside ornamental ponds.

Saule Pleureur

SUMAC
Family **Anacardiaceae**
Genus *Rhus*

This tree thrives in both temperate and tropical regions. The 150 or so species in this genus are loved by gardeners for the splendour of their autumn foliage. *Rhus coriaria*, tanner's sumac, grows in arid areas in southern France. Its Latin and English names both refer to its main characteristic, its tannin-rich leaves. Tanners would use it to make fine leathers, particularly Morocco leather (goatskin and lambskin). In the Middle East, where sumac also flourishes, its sour berries are pickled like capers. *Rhus glabra* owes its French name *vinaigrier* ('vinegar tree') to its bright red berries that are macerated in water to produce a sour beverage. This highly decorative North American species was introduced into Europe in the seventeenth century. It was quickly supplanted by the broader *Rhus typhina*, the staghorn sumac. In France, it is known as *sumac de Virginie* ('Virginia sumac') and *sumac amarante* ('amaranth sumac'), the latter because its cone-like clusters of velvety flowers resemble those of the same name. It is also known as *sumac à bois poilu* ('hairy-wood sumac') because its branches are velvety like deer antlers. The common French names of *Rhus vernicifera*, the Chinese or Japanese lacquer tree, indicate its origin and the use given to it. They were the first to use its resin as a lacquer, which they call *urushi*.

Sumac

ELDER
Family **Caprifoliaceae**
Genus *Sambucus*

The French name for this tree, *sureau*, is derived from the adjective *sur* ('sour') from the sourness of its reddish-black berries. In Greek mythology, elderberries were considered a food prized by the gods. These berries are slightly poisonous, although this is remedied by cooking. However, they should not be eaten raw. They are made into jams, elderberry wine and syrup, and kefir, a fermented beverage with a very low alcohol content, which can also be made using elderflowers. These bloom in large white umbels, which, mixed with the lush green serrated leaves of the tree, make a striking image. Although elder trees are common in the wild, they are little loved by gardeners. *Sambucus nigra*, the common elder, is native to Europe. Then medicinal properties of elderflowers were known to the ancient Greeks, who used them in infusions to reduce fevers or mouthwash to relieve a sore throat. These properties are now used in homeopathy. *Sambucus racemosa*, the red-berried elder, grows in the area between Europe and northern China. This tree is smaller than the common elder and is only suited to mountain regions. Its flowers and fruits appear before those of the common elder. The berries are made into a brandy typical of the Vosges region of France. Elder wood hardens with age. It can then be used for woodcut printing, making musical instruments and tobacco pipes. The pith wood of the tree was used to make pith helmets.

Sureau

SYCAMORE
Family **Moraceae**
Genus *Ficus*

This melodious and enchanting name is given to *Acer pseudoplatanus*, a maple of striking height and circumference. Most likely native to eastern Europe, it grows spontaneously in the mountains of France, except the Pyrenees, although it has responded well to being introduced into that region. However, the first tree to be called a sycamore is a fig tree, *Ficus sycomorus*. While it is native to central Africa, it is found all over that continent in addition to the Middle East and Madagascar. The sycamore fig loves rich soils and being near watercourses, but dislikes areas of tropical rainforest. It bears figs throughout the year, which turn from green to pinkish-yellow when ripe. The value of this asset is unfortunately lessened by its tendency to attract insect pests. The ancient Egyptians believed its wood to be incorruptible, and time has proved its remarkable durability. They shaped it into sarcophagi and statues, and used it to make lyres and tablets where they could carve their hieroglyphics. The sycamore fig grows to a circumference of six metres and a height of 20 metres. Its broad and dense crown, which spreads out from a knotted trunk, provides shade that is much appreciated in hot countries.

Sycomore

TEAK
Family **Verbenaceae** or **Lamiaceae**
Genus *Tectona*

The name of this tree is quite familiar to us ever since it began to invade our gardens. Not the living tree; it is strictly tropical. Rather, in the form of rot-resistant outdoor furniture, a good alternative to plastic. The qualities of its wood are on a par with those of the best oak. Teak was discovered by Europeans at the end of the seventeenth century. The tree later served for shipbuilding, indoor and outdoor flooring, bridges and furniture, among other things. Aboriginal Australians make their traditional wood instrument, the didgeridoo, out of its wood. Its leaves are also made into packaging and everyday objects, although this marginal use is limited to its natural habitat: India, Malaysia, Laos, Thailand, Myanmar (formerly Burma) and the Philippines. Teak grew spontaneously in these countries, before its cultivation spread to Indonesia in the seventh century. It thrives on suitable, well-drained land without any special care. As a result, teak plantations multiplied in Asia in the seventeenth century. The lucrative species was subsequently introduced into tropical regions of Africa and the Americas. Burmese teak remains the most regarded, but the resulting cross-border traffic means that the future does not look bright for this tree.

Teck

ARBORVITAE
Family **Cupressaceae**
Genus *Thuja*

This evergreen conifer – also confusingly known by the name of cedar – is tall and pointed, often leading to it being mistaken for a cypress. *Thuja occidentalis*, the American arborvitae or eastern white cedar, was the first North American species to cross the Atlantic. Jacques Cartier brought it back to France in 1534 from his first expedition, where King Francis I gave it the Latin name *arbor vitae*, 'tree of life', unwittingly mirroring the wisdom of the Canadian natives. *Thuja plicata*, the western red cedar, is also fittingly known as the giant arborvitae owing to the fact that it grows to a height of 50 metres. Introduced into France from the west coast of America in the mid-nineteenth century, it would be a perfect species for reforestation were it not for the bark of young plants being susceptible to the rust fungus. *Thuja orientalis*, the oriental arborvitae, a very modest shrub, is also known as the Chinese arborvitae after its country of origin. It has long been cultivated in Asia, but only arrived in Europe in the late seventeenth century. In winter, the oriental arborvitae can turn bronze, the effect of which is quite striking. Arborvitae trees are suited to being clipped. They even like it, producing shoots less than a year after being heavily cut back, which is the reason they are more often found in hedges than free-standing. Their soft and light but strong wood is used in cabinet-making, and their fan-shaped branches make excellent brooms.

Thuya

SANDARAQUE

LINDEN
Family **Tiliacaea**
Genus *Tilia*

Who has never drunk an infusion of linden flowers to make it easier to sleep? The tree's sweet scent alone is soothing. Aware of this, the Celts made the linden, also known as the lime tree, their astrological symbol for harmony. The ancient Greeks consecrated it to Aphrodite, the goddess of love. Was it because of its heart-shaped leaves? Nobody is certain. For the Germanic peoples it was also a symbol of love, the maternal variety this time, and they made it the tree of Frigga, goddess of fertility in Norse mythology. Medieval Christians considered it sacred and planted it around churches. The linden's aura was no less important in secular circles. In the east of France and Germanic countries, justice was meted out under its leaves, and in 1792, it was among the trees planted in large numbers to symbolize liberty. There has been nothing but admiration throughout history for this tree that grows widely all over the northern Hemisphere. Two European species, *Tilia cordata*, the small-leaved linden, and *Tilia platyphyllos*, the large-leaved linden, gave rise to the hybrid *Tilia intermedia*, the common linden. Its name is a good indication of its predominance over the thirty or so other linden varieties. Apart from the herbal tea made from the flowers and their leaf-shaped bracts, linden wood has been prized since ancient times. It is suitable for carving; its sturdy fibres are used to make rope, sacks and sandals; and its leaves are used as fodder for livestock.

Tilleul

EUROPEAN ASPEN
Family **Salicaceae**
Genus *Populus*

The common name for this tree has become such a part of everyday language that it is easy to forget that it is actually a member of the poplar family. The Latin name *populus* pays tribute to the diversity of poplars. The leaves of *Popula tremula* ('trembling poplar') the European aspen's scientific name, are attached to the stem by a long flattened stalk, known as a petiole. This allows them to tremble in the wind without coming detached from the branch, hence the name. The European aspen grows over a vast area, spanning between Lapland and Algeria, and between the Atlantic Ocean and Japan. As the tree loves cool climates, it grows abundantly on the plains of the north and in the mountains of the south. Like the other species in its family, it requires full sunlight. But unlike them, it will grow in forests, in clearings or along the edges. It also quickly colonizes lands burnt by fire. As a result, aspens overran the ruins of Moscow after the intentional fire lit by the city's governor (Count Rostopchin, father of the future Countess of Ségur) to deprive Napoleon's army of food and to compel it to retreat. Aspen wood is soft and it burns quickly, which made it the favourite of bakers for fuelling their wood-fired ovens. Turners and cabinet-makers prize its uniform grain and the ease with which it is worked. It is also used as pulp for making high-quality paper.

Tremble

INDIAN ALMOND TREE
Family **Combretaceae**
Genus *Terminalia*

———————————

The obsolete French name for this tree is the *vernis du Canada* ('Canadian lacquer tree'). It does not secrete a resin that can be used to make lacquer, but its bearing and foliage are reminiscent of those of *Rhus vernicifera*, the variety of sumac known as the Chinese or Japanese lacquer tree. Hence the likely mistake, but it is no longer of consequence. The Indian almond tree is actually native to New Guinea, and it has plenty of qualities. Its small bright pink fruit, resembling a lychee, is eaten in stages. First, the green or yellowish flesh around the nut is savoured. Then the shell is broken to reveal the kernel, which is eaten raw, dried or roasted. The wood of the Indian almond tree was traditionally used for canoes, and to build frames of houses. It also lends itself well to carving and for use as firewood. The bark has medicinal properties for the treatment of coughs and urinary infections. A decoction of its leaves serves to lower blood pressure. The leaves also have an original use in fish tanks: when immersed in the water of a tank, they release tannins with antiseptic properties. Used in this way, they contribute to preserving delicate fish species, such as the Asian discus, which is highly prized by enthusiasts.

———————————

Vernis du Canada

TABLE OF FAMILIES AND GENERA

Family	Genus	Species	English name
Aceraceae	Acer	Acer saccharum	Sugar maple
Anacardiaceae	Pistacia	Pistacia vera	True pistachio tree
Anacardiaceae	Rhus	Rhus coriaria	Tanner's sumac
Aquifoliaceae	Ilex	Ilex aquifolium	Holly
Araucariaceae	Araucaria	Araucaria imbricata	Monkey puzzle
Berberidaceae	Berberis	Berberis vulgaris	Common barberry
Betulaceae	Betula	Betula verrucosa	Silver birch
Bombacaceae	Adansonia	Adansonia fony	Baobab
Burseraceae	Dacryodes	Dacryodes excelsa	Gommier
Buxaceae	Buxus	Buxus sempervirens	Box
Caprifoliaceae	Sambucus	Sambucus nigra	Common elder
Celastraceae	Euonymus	Euonymus europaeus	European spindle tree
Combretaceae	Terminalia	Terminalia catappa	Indian almond tree
Cornaceae	Cornus	Cornus mas	Cornelian cherry tree
Cupressaceae	Cupressus	Cupressus sempervirens	Cypress
Cupressaceae	Thuja	Thuja occidentalis	American arborvitae
Ebenaceae	Diospyros	Diospyros ebenum	True ebony

Family	Genus	Species	English name
Euphorbiaceae	Hippomane	Hippomane mancinella	Manchineel
Fabaceae	Dalbergia	Dalbergia nigra	Brazilian rosewood
Fabaceae	Haematoxylum	Haematoxylum campechianum	Logwood
Fabaceae	Laburnum	Laburnum anagyroides	Common laburnum
Fabaceae	Robinia	Robinia pseudoacacia	Black locust
Fagaceae	Castanea	Castanea sativa	Sweet chestnut
Fagaceae	Fagus	Fagus sylvatica	Common beech
Fagaceae	Quercus	Quercus pedunculata	Common oak
Hippocastanaceae	Aesculus	Aesculus hippocastanum	Horse chestnut
Juglandaceae	Juglans	Juglans regia	Common walnut tree
Lauraceae	Cinnamomum	Cinnamomum camphora	Camphor tree
Lauraceae	Cinnamomum	Cinnamomum zeylanicum	Cinnamon tree
Lauraceae	Laurus	Laurus nobilis	Bay tree
Liliaceae	Dracaena	Dracaena draco	Dragon tree
Meliaceae	Swietenia	Swietenia mahogany	Mahogany tree
Moraceae	Castilla	Castilla elastica	Rubber tree
Moraceae	Ficus	Ficus sycomorus	Sycamore fig
Moraceae	Morus	Morus alba	White mulberry tree
Musaceae	Musa	Musa paradisiaca	Banana tree
Myristicaceae	Myristica	Myristica fragrans	Nutmeg tree

Family	Genus	Species	English name
Oleaceae	Fraxinus	Fraxinus excelsior	Ash
Oleaceae	Olea	Olea europaea	Olive tree
Palmaceae	Areca	Chrysalidocarpus lutescens	Areca palm
Palmaceae	Cocos	Cocos nucifera	Coconut palm
Palmaceae	Phoenix	Phoenix dactylifera	Date palm
Palmaceae	Raphia	Raphia ruffia	Raffia palm
Pinaceae	Abies	Abies pinsapo	Spanish fir
Pinaceae	Abies	Abies nordmanniana	Nordmann fir
Pinaceae	Cedrus	Cedrus libani	Cedar of Lebanon
Pinaceae	Larix	Larix decidua	European larch
Pinaceae	Picea	Picea glauca	White spruce
Pinaceae	Pinus	Pinus sylvestris	Scots pine
Platanaceae	Platanus	Platanus x acerifolia	London plane tree
Punicaceae	Punica	Punica granatum	Pomegranate tree
Rhizophoraceae	Rhizophora	Rhizophora mangle	Red mangrove
Rosaceae	Crataegus	Crataegus azarolus	Hawthorn
Rosaceae	Cydonia	Cydonia oblonga	Quince tree
Rosaceae	Malus	Malus pumila	Apple tree
Rosaceae	Prunus	Prunus amygdalus	Almond tree
Rosaceae	Prunus	Prunus armeniaca	Apricot tree
Rosaceae	Prunus	Prunus avium	Wild cherry tree

Family	Genus	Species	English name
Rosaceae	Prunus	Prunus cerasus	Sour cherry tree
Rosaceae	Prunus	Prunus domestica	Plum tree
Rosaceae	Prunus	Prunus persica	Peach tree
Rosaceae	Pyrus	Pyrus communis	Pear tree
Rosaceae	Sorbus	Sorbus domestica	Service tree
Rubiaceae	Cinchona	Cinchona officinalis	Peruvian bark
Rutaceae	Citrus	Citrus limon	Lemon tree
Rutaceae	Citrus	Citrus sinensis	Orange tree
Salicaceae	Populus	Populus nigra	Black poplar
Salicaceae	Populus	Populus tremula	European Aspen
Salicaceae	Salix	Salix alba	White willow
Salicaceae	Salix	Salix babylonica	Weeping willow
Santalaceae	Santalum	Santalum album	Indian sandalwood
Sterculiaceae	Theobroma	Theobroma cacao	Cocoa tree
Taxaceae	Taxus	Taxus baccata	Common yew
Tiliacaea	Tilia	Tilia intermedia	Common linden
Ulmaceae	Celtis	Celtis australis	European nettle tree
Ulmaceae	Ulmus	Ulmus campestris	Field elm
Verbenaceae	Tectona	Tectona grandis	Teak
Zygophyllaceae	Guaiacum	Guaiacum sanctum	Lignum vitae

FURTHER READING

Blackwell (Lewis), *Arbres extraordinaires*,
Éditions du Chêne, 2009.

Brosse (Jacques), *Larousse des arbres. Dictionnaire des arbres et des arbustes*, Larousse, 2004.

Hallé (Francis), *Plaidoyer pour l'arbre*, Actes Sud, 2005.

Jullien (Élisabeth) and Jullien (Jérôme), *Guide écologique des arbres*, Eyrolles, 2009.

Mansion (Dominique), *Les Trognes : l'arbre paysan aux mille visages*, Ouest-France, 2010.

Pollet (Cédric), *Écorces. Voyage dans l'intimité des arbres du monde*, Eugen Ulmer Éditions, 2008.

Spohn (Margot), Spohn (Roland), *350 Arbres et arbustes*, Delachaux and Niestlé, collection « les Indispensables », 2008.

www.lesarbres.fr

ALSO AVAILABLE

- The Little Book of Birds
- The Little Book of Cats
- The Little Book of New York
- The Little Book of Versailles
- The Little Book of Medicinal Plants
- The Little Book of Paris
- The Little Book of Roses
- The Little Book of Dogs
- The Little Book of the language of Flowers
- The Little Book of Nativity

All images are from the private
collection of Albert Van den Bosch (www.collectomania.be),
except p. 6 and p. 10 © akg-images.
Cover (chromo print): © Selva/Leemage.

For the original edition:
© 2012, Éditions du Chêne – Hachette Livre

For the current edition:
Editorial Director: Jérôme Layrolles
Editor: Eglantine Assez
Art director: Charles Ameline
Production Controller: Cécile Alexandre-Tabouy
English Edition: Ariane Laine-Forrest

Translation © Papier Cadeau – Hachette Livre, 2019
English translation and proofreading by John Ripoll
and Laura Gladwin for Cillero & de Motta

Published by Papier Cadeau
(58, rue Jean Bleuzen, 92178 Vanves Cedex)
Printed by Toppan Leefung in China
Printed in January 2020
ISBN: 978-2-37964-103-9
13/0941/7-01